A pocket g
Carlton W;

CW00499038

Dr Czes & Yvonne
Kosniowski

ckyk publishing

Acknowledgments

We would like to thank everyone that has supplied us with information or photographs, or allowed us to photograph their Carlton Ware. It is not possible to mention everyone here and many wish to remain anonymous.

We would like to mention a few that have been particularly helpful. These include Ian Harwood, Jerome Wilson, Tyrone Santa Maria, Richard Coates, Harvey Pettit, Peter Davy, Diana Kearns, Glenn Fullerton, Steve Jessup, Billy Strachan, Mike Maunder, Allan Bellamy, Peter Richmond, Robin Bix, Jane Crossen, Tony & Kath Marsden, David Vernam, Keith Burdis, Beverley and Beth.

Published by ckyk publishing, a division of ckyk ltd.

ISBN 0-9549558-0-3

Contents

A guide to Carlton Ware

Introduction

This book is for everyone interested in Carlton Ware. It will appeal to beginners, small collectors, large collectors and dealers etc.

Our aim was to produce a valuable and comprehensive source of information in an easy to use format. It will prove to be a very useful reference tool and help you identify the many hundreds of pieces of Carlton Ware available. The compact size means it is ideal to take to fairs, auctions, exhibitions, etc. The restriction of size means that we have not been able to show every colourway, shape or size of a pattern. This would have required the book to be very large and not very portable.

Obviously patterns and shapes do come in a number of different colourways. This book essentially ignores colours for identification purposes and we usually show only one piece of from the many different colourways and shapes. Often we just show part of the piece to highlight the pattern. As a consequence we were unable to give any indication of prices as this does depend upon a variety of factors such as rarity, age, size, colour and of course market forces .

We have provided pictures of the various Carlton Ware as

an aid to identifying patterns. The guide is in two parts. The first part is patterns identified by pattern numbers; the second by shape numbers.

Patterns and Shapes

Carlton Ware used Pattern numbers and Shape (or Impressed) numbers to identify items. The pattern number identified the actual pattern including the colour of the piece; whilst the shape number identified the shape (and size).

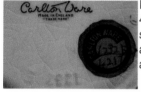
In this picture the Pattern Number 4217 is on a paper sticker. The shape number 1232 and size E also appears on the paper sticker as well as being impressed.

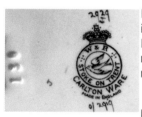
In this picture the Pattern Number is 2929 and the Shape or Impressed Number is 130. The marking o/2919 is an order number.

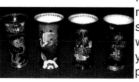
Impressed or Shape numbers refer to the "shape". For example, shape 217 is a 6 inch tall vase which has been made over many years and in many different patterns (four are shown here).

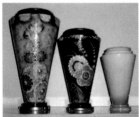

Often an impressed number is followed by a space or "/" followed by further characters. These refer to the "size" of the Carlton Ware piece. For example these three pieces of Carlton Ware have the conical shape 111 and sizes 10, 8 and 6 respectively.

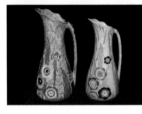

With the embossed range of Carlton Ware the "shape" also uniquely identifies the pattern. For example, shape 975 is a Flower Jug with the "Anemone" pattern.

A list of pattern numbers and shape numbers may be found towards the end of this book.

A Brief History of Carlton Ware

Carlton Ware began life in 1890, with a partnership by J. F. Wiltshaw and J. A. & W. H. Robinson. This gave birth to a company that lasted for more than a century albeit with many changes of ownership. Today Carlton Ware is well known and collected all over the world.

The early Carlton Ware products were the Victorian Blush Ware which were very popular at the time. At the turn of the century, the Crested Ware line was introduced followed

by matt black ware with floral decorations and a range of 'Cloisonne' which was outlined in gilt to resemble the well known jewellery range.

The 'Oriental' designs were introduced between the two World Wars. This, combined with a series of lustre finishes, put Carlton Ware at the forefront of the market. Today sought after designs include Babylon, Persian Garden, Devil's Copse, Red Devil, Fantasia, Chinaland, Mandarins Chatting, Crested Bird & Water Lily, Chinese Bird, Bell etc. Other sought after designs are the Tutankhamen range and anything produced in the Art Deco period.

By the late 1920's, the range of Carlton Ware had expanded to include more modestly priced tableware, and Carlton Ware was the first manufacturer to offer 'Oven to Table' wares in 1929.

By the mid 1930's, the Japanese had become very proficient at copying good quality wares and Carlton Ware became a target for them. Their prices for the imitations were much lower than the genuine originals. Carton Ware discovered a clause in the 'South East Asia Treaty Organisation' which concerned Australia and Japan. This treaty stated that the Japanese could not copy designs registered in Australia. Carlton Ware took advantage of this treaty and registered a large number of designs in Australia. This explains the "Registered Australian Design" back stamp.

World War II effectively stopped the production of anything except utility wares. However, during this period, new production methods were introduced and the lustre ranges were produced in the Royale range of colours. The Royale colours were called Bleu, Rouge, Vert and Noire (Blue, Red, Green and Black respectively). Apart from black, these new colours were much more uniform and were easily distinguishable from the pre-war versions which tended to be mottled and have some visual texture. New hand-painted decorations were also added to include Spider's Web, New Mikado, and New Stork. In parallel with these finer wares, fruit and floral designs also continued to made and were increased to include Hydrangea, Vine and Grape, Poppy, and Daisy.

The 1950's was probably the most productive period in the Carlton Ware history. Most of the Carlton Ware being produced now contained the word 'Handpainted' on the back stamp, regardless of whether it was or wasn't. Windswept, Leaf and Pinstripe were added to the range and a steady production of lustre wares was maintained. In 1958, the company officially changed its name to Carlton Ware Ltd.

The 1970's led to the introduction of the 'Walking Ware' range. This gained immediate popularity.

With the recession in the early 1980's the Receivers were called into the Copeland Street works in 1989. Although there was a short period of production of Carlton Ware

between 1990 and 1992, the name then remained dormant until 1997 when Francis Joseph acquired it together with a small number of moulds and a few pre-production models.

One sad aspect about Carlton Ware is the amount of material which has been lost or is not available. Patterns and shapes appear regularly which do not exist in any of the known records. Given time it may be able to reconstruct the entire history of Carlton Ware and its pieces. We have done our best to present the information about Carlton Ware in a correct way. Occasionally mistakes may be made and we apologise in advance for any error that may occur. Please let us know if you believe or know of any error. Our current email address may be found on the www.carltonware.com web site

Duplicate Numbers

One of the frustrations with Carlton Ware is the fact that some pattern numbers haven't always been used in a unique way. This remains one of the mysteries of the whole Carlton Ware story. We shall take a brief look here at some Carlton Ware items which have the same pattern numbers but are different in some significant way.

The Carlton Ware Web Site has several dozen pairs of patterns that are listed with the same number but have a different description. No doubt some of these will be pure errors where someone has misread or misquoted a number. For example a 4 and a 7 can often be confused.

The numbers in the pictures here look quite clearly like 2041 and 2071 respectively. Yet the pictures were taken from Carlton Ware vases with the same pattern and same colourway. We believe that the correct number is 2071 and that the "4" is a poorly painted "7".

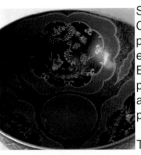

Sometimes you will find a piece of Carlton Ware with part of the pattern may be missing. For example, 2175 is the Worcester Birds pattern. But, there are pieces with this pattern number and no Worcester Birds. See the pictures on the left.

There are several other similar examples where part of the expected pattern is missing. For instance, 2428 New Mikado, 2927 Mikado and 3891 Sketching Bird.

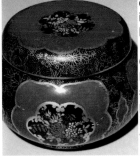

One might think that such pairs have been produced by accident, simply by omitting part of a pattern. Although this is possible it is quite likely that some pieces were produced by design. Indeed,

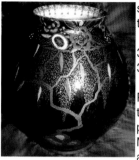

some pairs are so common that they each have a name:

3672 Mandarin Tree
3672 Mandarins Chatting

Pictures of these are shown on the left. The Mandarins Chatting pattern is basically the same as Mandarin Tree pattern but with the addition of the "Mandarins".

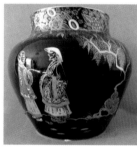

Other examples include:

3765 Red Devil (Mephistopheles)
3765 Devil's Copse

3769 Red Devil (Mephistopheles)
3769 Devil's Copse

These pattern pairs are basically the same except that the Red Devil or Mephistopheles pattern also has the "Red Devil".

Sometimes the different patterns with the same pattern number were distinguished by adding a letter A or B after the pattern number.

11

Other interesting pairs involve one piece with a pattern and another completely plain. For example:

4158 Plain pale yellow or cream with gilt.

4158 Babylon on pale yellow or cream with gilt.

There are several other examples like this where one piece has a "pattern" while others are "plain".

An intriguing example is 4108 which has three different patterns on pale green.

4108 Plain pale green with gilt
4108 Heron & Magical Tree on pale green
4108 Temple on pale green

This is peculiar because, although the ground colour is the same on each, we do have completely unrelated patterns. This is where it may be argued that one of the latter two have had their number incorrectly read or marked. Perhaps time will tell.

Other examples of pairs with the same pattern numbers include pieces with the "same" pattern but different colourways. There are a few examples on the Web Site. Two such examples are:

3244 Forest Tree with blue ground and mauve foliage
3244 Forest Tree with green ground and mauve foliage

2907 Magpies on red ground
2907 Magpies on blue ground

These different colourways often appear to have been distinguished by having a letter A or B added after the pattern number.

Finally we have examples where the patterns are different and the colourways are different. For example

3965 Heron and Magical Tree on cream ground.
3965 Plain Rouge Royale.

We have received many examples of this particular pair from several different sources. It is therefore unlikely to be just the case of one person misreading a number.

There are several other examples of pairs of Carlton Ware with the same pattern numbers which have caused confusion because the numbers were hand painted or written on to a sticker. With the impressed or shape numbers the situation is slightly better. The impressed numbers were in the mould and as such would presumably always be correct. However they can still sometimes be difficult to read and lead to mistakes.

Dating Carlton Ware

Background

To help date Carlton Ware you need to look at the Carlton Ware (or W&R) back-stamp or logo, the pattern number (usually hand painted) on the base and the impressed number on the base. Sometimes the pattern numbers and the impressed numbers are not present or are very difficult to read. In the later years the pattern number was written on a paper sticker attached to the base of the piece and often this has been removed!

In this picture the Pattern Number is 2929 and the Shape or Impressed Number is 130. The marking o/2919 is an order number.

The Pattern Number 4217 on a paper sticker. The shape number 1232 and size E appears on the paper sticker as well as being impressed.

14

Back-stamp or Logo

The following list provides a rough indication of the date that a piece of Carlton Ware was made by looking at the back-stamp.

 Ribbon or Blue Bird 1890 - 1894

 Crown 1894 - 1927

 Crown variation 1906 - 1927

 Carlton China Crown 1906 - 1927

 Armand Lustre, Late 1910's - early 1920's

 Carlton China 1925 - 1957

 Script 1925 - 1970

 Handcraft 1929 - 1939

 Ovenware 1929 - 1942

 Australian 1935 - 1961

"Rouge Royale" Rouge Royale (Red). 1940+

"Vert Royale" Vert Royale (Green). 1940+

"Bleu Royale" Bleu Royale (Blue). 1940+

"Noire Royale" Noire Royale (Black). 1940+

Carlton Ware Handpainted 1952 - 1962

Curved 1967 - 1989

Carlton Ware ENGLAND Plain 1968 - 1990

Carlton Ware MADE IN ENGLAND

©Carlton Ware ENGLAND LUSTRE POTTERY Lustre Pottery 1974 - 1989

Pattern Numbers and Dates

Pattern numbers give an approximate date of manufacture. The list below gives an approximate date range for various pattern number ranges.

Pattern Number	Approximate Dates
up to 2000	up to 1916
2001 to 2700	1916 to 1923
2701 to 4000	1923 to 1936
4001 to 4500	1936 to 1940
4501 onwards	1940 onwards

Shape Numbers and Dates

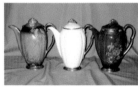

The impressed or shape numbers are not always useful for dating an item. For example the impressed number 1582 was first introduced in the late 1930's. It was used for Coffee Sets for several years. This picture shows three Coffee Pots, all with the same impressed number 1582 but with different patterns and different pattern numbers.

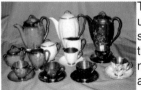

The impressed number 1582 was used for Coffee Sets and as such sets were sold in sets, all items in the set had the same impressed number. The picture here contains a selection of items from Coffee

18

Sets including Coffee Pots, Milk Jugs, Sugar Bowls, Cups and Saucers. All have the same impressed number 1582.

The following table indicates approximately when a shape was first introduced. These dates will only indicate how old the item might be but cannot be a guarantee of its age.

Shape or Impressed Number	Approximate Dates when first introduced	Example
Upto 1000	upto 1934	Crab and Lobster salad ware, Fruit Basket
1000 - 1100	1934	Gum nut, Anemone
1100 - 1200	1934 - 1935	Oak
1200 - 1300	1935	Rock Garden, Hangman Mug
1300 - 1400	1935 - 1936	Lettuce, Buttercup
1400 - 1500	1936 - 1937	Tulip, Daisy, Blackberry, Raspberry
1500 - 1600	1937 - 1938	Water Lily, Wild Rose, Crocus
1600 - 1700	1938 - 1939	Red Currant, Apple Blossom
1700 - 1800	1939	Water Lily, Crocus, Pyrethrum, Clover, Shamrock, Narcissus, Begonia, Campion
1800 - 1900	1939 - 1940	?

1900 - 2000	1940 - 1945	Foxglove, Basket, Chestnut, Clematis, Primula, Cherry, Wallflower
2000 - 2100	1945 - 1950	Delphinium, Apple Blossom, Poppy, New Buttercup, New Daisy, Poppy and Daisy, Hydrangea
2100 - 2200	1950 - 1953	Vine
2200 - 2300	1953 - 1955	Grape
2300 - 2400	1955 - 1958	Guinness figures, Hazel Nut, Leaf Salad
2400 - 2500	1958 - 1959	Windswept, Pinstripe, Langouste (Lobster, Crayfish), Convolvulus
2500 - 2600	1959 - 1964	Magnolia, Orchid
2600 - 2700	1964 - 1968	Guinness Penguin Lamp, Carlton Village
2700 - 2800	1968	Guinness items, Tapestry
2800 - 2900	1968 - 1969	Military, Persian Tea & Coffee sets, Skye Tea & Coffee sets
2900 - 3000	1969 - 1970	Canterbury Tea & Coffee sets
3000 - 3100	1970 - 1971	Owl, Bird etc, Late Buttercup
3100 - 3200	1971 - 1976	Early Walking Ware, Apple Blossom, Later Walking Ware
3200 - 3300	1976 - 1980	Dovecote, Hovis

3300 - 3400	1980 - 1985	Charles & Di, Walking Ware Big Feet
3400 - 3500	1985 - 1986	Robertson Golly
3500+	1986+	Coronation Street

Dating by the British Registered Design Number

Carlton Ware designs were sometimes registered and the British Registered Number often appears on the bottom of some pieces of Carlton Ware, particularly the older W & R pieces.

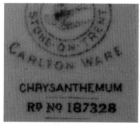

Registered Number 187328, registered in 1892

The following list of Registered Design numbers and approximate dates may be of help in identifying the date of manufacture.

Note that a design might have been in continuous production for many years after being registered, so dates should not be taken as dates of manufacture. Note also that for simplicity we have rounded off the Registered numbers to the nearest hundred.

Year	Rd No	Year	Rd No	Year	Rd No
1884	1 -	1917	659000 -	1950	860900 -
1885	19700 -	1918	662900 -	1951	863100 -
1886	40500 -	1919	666100 -	1952	866300 -
1887	64500 -	1920	673700 -	1953	869300 -
1888	90500 -	1921	680100 -	1954	872500 -
1889	116600 -	1922	687100 -	1955	876100 -
1890	141300 -	1923	695000 -	1956	879300 -
1891	163800 -	1924	702700 -	1957	882900 -
1892	185700 -	1925	710200 -	1958	887100 -
1893	205200 -	1926	718100 -	1959	891700 -
1894	224700 -	1927	726300 -	1960	895000 -
1895	247000 -	1928	734400 -	1961	899900 -
1896	268400 -	1929	742700 -	1962	904600 -
1897	291200 -	1930	751200 -	1963	909400 -
1898	311700 -	1931	760600 -	1964	914500 -
1899	331700 -	1932	769700 -	1965	919600 -
1900	351200 -	1933	779300 -	1966	924500 -
1901	368200 -	1934	789000 -	1967	929300 -
1902	385200 -	1935	799100 -	1968	934500 -
1903	402200 -	1936	808800 -	1969	939900 -
1904	424400 -	1937	817300 -	1970	944900 -
1905	447800 -	1938	825200 -	1971	950000 -
1906	471800 -	1939	832600 -	1972	955300 -
1907	494000 -	1940	837500 -	1973	960700 -
1908	518600 -	1941	838600 -	1974	965200 -
1909	535200 -	1942	839200 -	1975	969200 -
1910	552000 -	1943	840000 -	1976	973800 -
1911	574800 -	1944	841000 -	1977	978400 -
1912	594200 -	1945	842700 -	1978	982800 -
1913	612400 -	1946	845500 -	1979	987900 -
1914	630200 -	1947	849700 -	1980	993000 -
1915	644900 -	1948	853300 -	1981	998300 -
1916	653500 -	1949	857000 -	1982	1004500-

Carlton Ware Patterns

This part of the book provides an identification guide to Carlton Ware by patterns.

Patterns come in a number of different colourways and almost always will have a different pattern number for each colourway. This book essentially ignores colours for identification purposes as we usually show only one piece of Carlton Ware from the many different colourways. Sometimes we just show part of the piece to highlight the pattern.

A list of some of the different pattern numbers are listed next to a pattern or shape. You can always look at our web site www.carltonware.com for more pictures classified by pattern number and colour.

An index of Pattern numbers and the page on which a picture of that pattern may be found is included towards the end of this book.

The pictures have been listed historically, approximately. The older patterns are towards the beginning and the newer patterns towards the end.

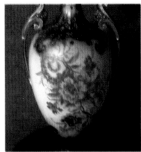

Blushware

Blushware is a generic term used to describe a characteristic decorating technique of subtle shading. Produced by Carlton Ware in the late 1880's.

The decoration on the ware usually consisted of a variety of floral designs and gilding.

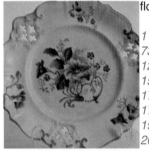

110, 253, 524, 585, 649, 670, 732, 975, 1075, 1219, 1230, 1246, 1340, 1414, 1509, 1518, 1572, 1621, 1635, 1664, 1681, 1739, 1747, 1749, 1752, 1786, 1799, 1848, 1863, 1869, 1902, 1928, 1935, 1942, 2040, 2366, 2659

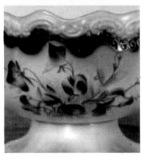

Blushware - Sweet Violet

Sweet Violet flowers and foliage on pale pink and cream ground.

142

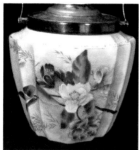

Blushware - Camellia

Camellia flowers and leaves on a pale cream ground.

184, 425, 843, 848, 849, 1153, 2300, 2700

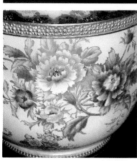

Blushware - Peony

Peony flowers and leaves on blushware.

194, 538, 945, 1034, 1658, 1661, 1682, 1683, 1832, 1839, 1853, 1996, 2691, 2853

Flow Blue - Florida

Flow blue, flowers and leaves in blue and gilt with gilt background.

220

Blushware - Violet

Violet flowers with foliage on blushware.

237, 1315, 1332

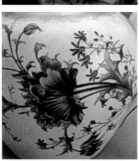

Blushware - Poppy

Poppies and leaves on blushware.

303, 305, 306, 307, 1015, 1770

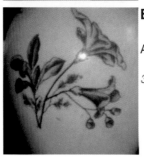

Blushware - Azalea

Azalea flowers on blushware.

347

Blushware - Convolvulus

Convolvulus flowers on blushware.

376, 2662, 2669

Blushware - Rosebud

Small rosebuds on blushware.

403

Blushware - Chrysanthemum

Chrysanthemum flowers and leaves on blushware.

406, 407, 409, 504, 639, 1089, 1091, 1372, 2407

Blushware - Arvista

Arvista flowers on blushware.

428, 476, 561, 1031, 1057, 1630, 1652, 1879, 1946, 1990, 2561, 2562

Blushware - Dianthus

Carnation like flowers and leaves on blushware.

438, 458

Blushware - Roses

Roses on pale cream ground blushware.

439, 913, 1221

Blushware - Carnation

Carnation flowers and leaves on blushware.

483, 1038, 1733

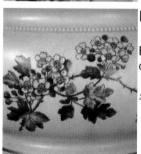

Blushware - Royal May

Blossom like flowers and leaves on blushware.

508, 602, 1229

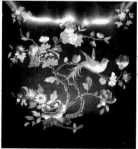

Chinese Quail

Bird with plumed tail perched on the branch of tree with brightly coloured flowers. Black ground.

522

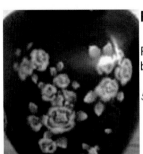

Red Rose

Red roses and leaves on matt black ground.

528

Flow Blue - Catalpa

Catalpa.

547

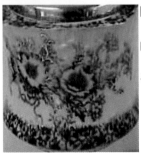

Flow Blue - Arvista

Poppy like flowers on Flow Blue.

561

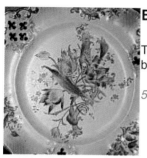

Blushware - Tulips

Tulip flowers and leaves on blushware.

578

Bird & Tree Peony

Small bird perched on Peony like blossoms.

595, 2466, 2866

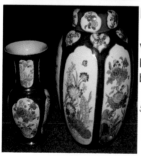

Kang Hsi

Variety of flowers, blossom and leaves on white ground within blue bordered cartouches.

596, 599

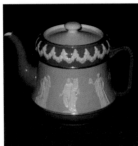

Grecian Figures

Frieze with garland of white foliage and white Grecian style figures raised as in Wedgwood.

601, 602, 604

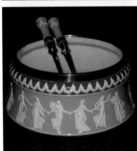

Dancing Figures

Frieze with garland of white foliage and white Grecian style dancing figures raised as in Wedgwood.

614, 2178, 2284

Blushware - Carnation Spray

Carnation flowers and leaves on blushware.

621, 1242

Reproduction Swansea China

Colourful posies of flowers in gilt cartouches with decorative gilt leaves and bands.

624

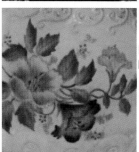

Blushware - Hibiscus

Hibiscus flowers and leaves on blushware.

634, 638, 2166

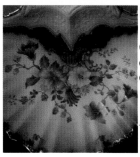

Blushware - Cornucopia

Collection of flowers also has a cone shaped horn within the decoration on blushware.

637, 653, 739, 832, 1002, 1162, 2083, 2086, 2474

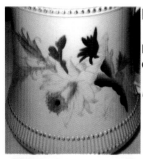

Blushware - Daffodil

Daffodil flowers and dark leaves on blushware.

641

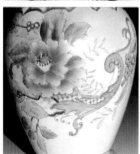

Blushware - Wild Rose

Rose flowers and leaves with stems in cornet shaped container on blushware.

659, 1123, 1125, 1918, 1939, 1947, 1974, 2215

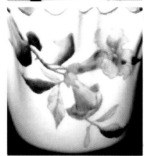

Catalpa

Flowers and leaves.

661

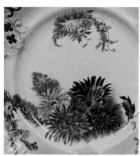

Blushware - Dahlia

Spiky Dahlia flowers on blushware.

682, 683, 735, 878, 1741, 1982, 2458

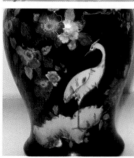

Stork

White Stork bird standing within insets of colourful flowers and leaves. Cloisonne Ware.

722, 723

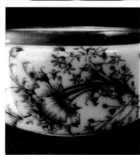

Flow Blue - Poppy

Blue lined design of poppies on white gloss ground.

751, 752, 1006

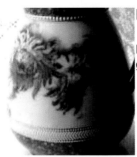

Flow Blue - Diadem

Large blue flower heads on white ground.

777

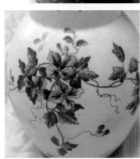

Blushware - Clematis

Clematis flowers and climbing leaves on blushware.

821, 826

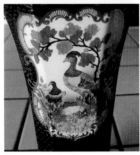

Pheasant Cartouche

Cartouche containing brightly coloured exotic birds, flowers, foliage and butterflies.

827

Insects

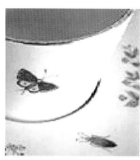

Insects and foliage on white ground.

850

Plain

Plain colours, although they may be finished with some gilt decoration in the form of edging, handles or interiors.

852, 2917, 3065, 3843, 3844, 3846, 3849, 3911, 3933, 3965, 4009, 4011, 4013, 4021, 4037, 4100, 4108, 4109, 4110, 4141, 4142, 4146, 4149, 4157, 4158, 4166, 4178, 4179, 4181, 4183, 4188, 4274, 4284, 4341, 4350, 4356, 4357, 4397, 4417, 4437, 4484, 4506, 4525, 4841

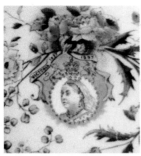

Blushware - Queen Victoria

Sprays of flowers and medallion containing an image of Queen Victoria on blushware.

856

Blushware - Nouveau Poppies

Art Deco style Poppies on pale cream ground.

886, 888

Blushware - Heather

Heather flowers on blushware.

1166, 1713, 1742, 2455, 2713, 2718, 2757

Flow Blue

Flowers in blue and colours edged in gilt.

1274, 1406, 1631, 1950, 2319

Blushware - Dog Rose

Dog Rose flowers and leaves on blushware.

1400, 1524

Flow Blue - Iris

Iris like flowers and gilt.

1422, 1750

Blushware - Petunia

Petunia flowers and leaves on blushware.

1451, 1453, 1467, 1810, 1987, 2007

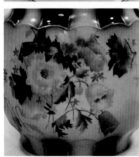

Blushware - Cistus

Colourful spray of flowers on blushware.

1474, 1769, 1804, 2494, 2798

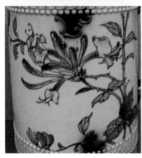

Blushware - Honeysuckle

Honeysuckle flowers on blushware.

1601

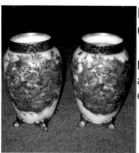

Flow Blue - Chrysanthemum

Blue Chrysanthemum flowers with a heavy backdrop of gilt, also edged in gilt.

1635

Blushware - Diadem

Thistle like flowers on blushware.

1650

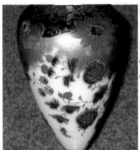

Flow Blue - Marguerite

Patterns of flowers in cobalt blue outlined in gilt. Gold floral design on cream ground. Flow Blue.

1655, 2301

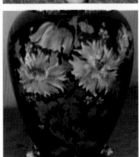

Chrysanthemum

Large blue Chrysanthemum flowers and gilt leaves.

1775

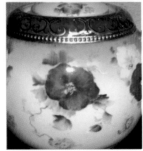

Blushware - Mixed Cottage

Pansy like flowers and leaves.

1795

Mikado

Chinoiserie design with a variety of trees, also chinese pagodas, bridges and oriental ladies. This design usually has a pair of kissing birds in flight.

1886, 2199, 2240, 2264, 2270, 2314, 2340, 2355, 2356, 2357, 2361, 2364, 2399, 2422, 2442, 2470, 2978, 3048, 3910, 4373, 4422, 4433, 4434, 4678

Sometimes there is a frieze which often has a "Temple" pattern such as in the following patterns:

1883, 2410, 2881, 2910, 2914, 2927, 3158, 3201

Almond Blossom

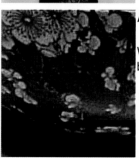

White Almond Blossom flowers on branches of trees .

1905, 2445, 3033

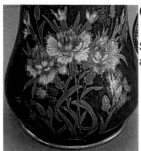

Carnation

Sprays of carnations with enamels and ornate gilt foliage.

1981

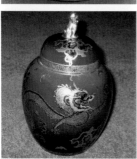

Dragon

Oriental dragon with fierce expression and long swirling shaped body in gilt and colours.

2006, 2053, 2062, 2064, 2066, 2067, 2102, 2103, 2818, 2993, 3251, 4717, 4914

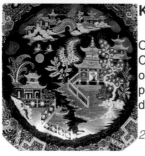

Kang Hsi Chinoiserie

Oriental design with trees and Chinese Pagodas, one has an ornamental wall and one has a post fence. A gold sun and a decorative frieze of oriental motifs.

2021

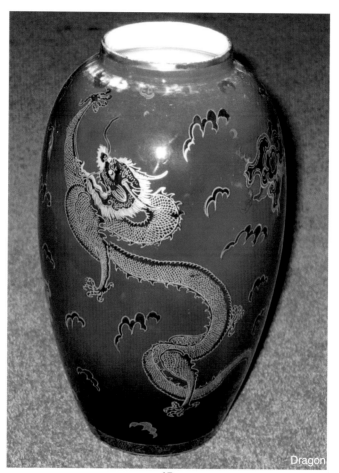

Dragon

45

Peach Blossom

Pink and green blossom sprays.

2030, 2371, 2436, 2480

Kien Lung

Birds on prunus blossom and flowers within cartouches of good luck symbols.

2031, 2053

Cartouche of Flowers

Cartouche containing flowers also has Chinese symbols. The pattern is also called "Seasons".

2033, 2216

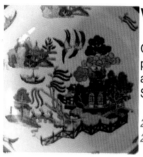

Willow

Chinoiserie design of willow trees, pagodas, bridge and a fence. Also a pair of kissing birds in flight. Similar to Mikado.

2041, 2341, 2351, 2352, 2841, 2851

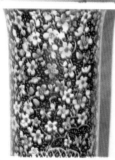

Chintz

Vividly decorated with intensely packed (usually) multi-coloured flower heads.

2046, 2047, 2069

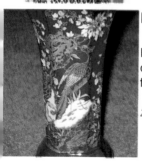

Rockery & Pheasant

Pheasant amongst a rockery of ornately enamelled flowers, foliage and a pretty butterfly.

2071, 2244

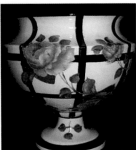

Rose Trellis

Realistic Roses and leaves on a white ground amidst black lines painted in a trellis style.

2080

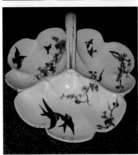

Birds and Blossom

Variety of birds in flight, including swallows and blossom on a white ground.

2089

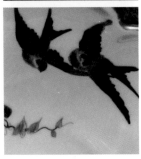

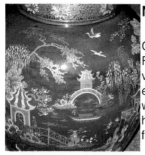

New Mikado

Chinoiserie design of Chinese Figures, Pagodas, Bridges and a variety of trees decorated with enamels, including a weeping willow tree. Usually this design has two crane like birds either in flight or wading.

2091, 2428, 2727, 2728, 2729, 2740, 2788, 2814, 2815, 2825, 2830, 2990, 3137, 3495, 3843, 3860, 4104, 4109, 4320, 4328, 4329, 4346, 4362, 4398, 4416, 4419

Flies

Beautiful, realistic large and small butterflies or moths on lustre finish.

2093, 2095, 2099, 2105, 2109, 2112, 2131, 2133, 2134, 2420, 2456, 2469, 2473, 2939

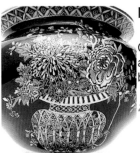

Basket of Flowers

Ornately enamelled formal arrangement of flowers in a basket.

2124, 2151, 2184, 2185, 2189

Pink Carnation

Realistic Spray of Pink Carnations and leaves on matt black ground.

2143

Worcester Birds

Enamelled crested bird design set in decorative cartouche panels.

2145, 2175, 2195, 2196

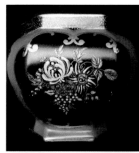

Worcester Birds without Birds

Enamelled floral design set in decorative cartouche panels.

2175

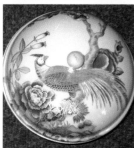

Long Tailed Bird and Tree Peony

A long tailed exotic bird perched on a branch with Peony like flowers and buds.

2186, 2634, 2832, 2834

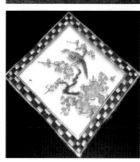

Bird & Chequered Border

Cartouche with black and white chequered border containing a bird design.

2221

Blushware - Daisies

Spray of Daisy flowers on pale cream ground, blushware.

2227

Cock & Peony

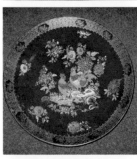

Two cockerels standing amongst a rockery of foliage. Also has a variety of beautifully enamelled flowers including Peony flowers. Sometimes has a "Cock & Peony" backstamp.

2250, 2280, 2281, 2282, 2287, 2308, 2398

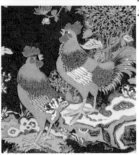

Roses

Realistic Roses and leaves on a black ground.

2286

Blushware - Primula

Brightly coloured Primula flowers and leaves on blushware.

2309

Lovebirds

Two Lovebirds nestled close together in a tree, Armand backstamp.

2326, 2328, 2782

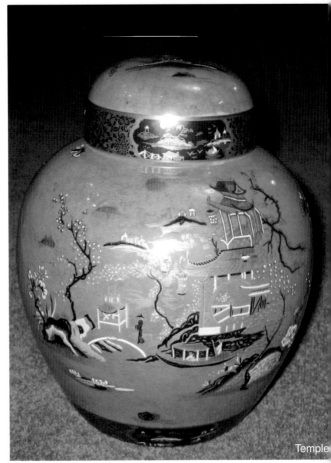

Temple

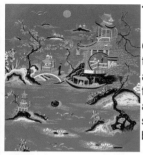

Temple

Oriental scene of figures in a temple with large circular doorway and lanterns. Ornately enamelled flowers and trees with black trunks and branches. Also has a golden sun and sometimes a punt like barge.

2367, 2481, 2482, 2552, 2681, 2820, 2880, 2928, 2929, 2941, 2971, 3003, 3026, 3027, 3047, 3048, 3087, 3129, 3130, 3130, 3185, 4108, 4204, 4205, 4208, 4214

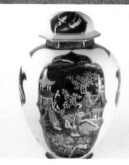

Mikado in Cartouche

Chinoiserie design of pagodas, bridges, oriental ladies and usually a pair of kissing birds in flight.

2368, 3178

Fairy and Sunflower

Pretty Fairies with beautiful ornately decorated wings sitting on large bright yellow sunflowers. Also has butterflies on a pale blue ground. Armand backstamp.

2369

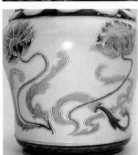

Cornflower

Cornflower like flowers with swaying stems and leaves on a pale ground.

2385, 2392

Prunus and Bird

Bird perched on prunus blossom tree with colourful sprays of flowers.

2412, 2413, 2421, 2431, 2831

Fish & Seaweed

Beautiful realistic looking fish swimming amongst seaweed in gilt.

2437, 2440, 2441, 3360

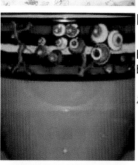

Berries and Bands

Brightly coloured berries like beads on multi-coloured bands.

2446, 2454, 2461, 2931

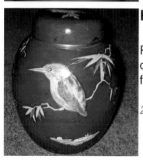

Kingfisher

Realistic Kingfisher bird perched on branch of a tree, sometimes in flight.

2517, 2530, 2537, 2858

Barge

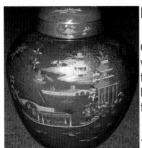

Chinoiserie design of water scene with punt like boat and lilies floating on the water. Also usually has a Chinese pagoda, bird in flight and a golden sun

2519

Italian Scenes

Market scene in Italy (Genoa) decorated in gilt.

2591

Eighteenth Tee

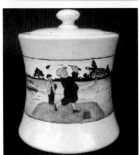

Playing Golf on the 18th tee.

2633

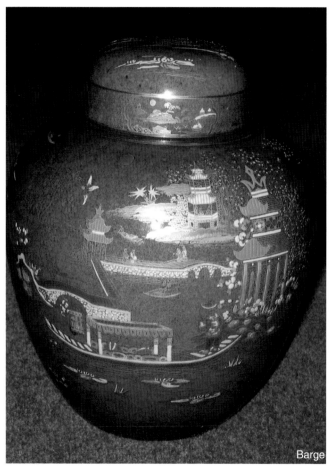

Barge

Moderne Lady

Moderne Lady in 18th/19th century dress.

2654

Tutankhamen

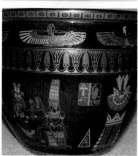

Egyptian figures, motifs and the winged figure of the Sun god Isis. Inspired by the artifacts at the burial chambers of Tutankhamen.

2686, 2689, 2706, 2708, 2709, 2710, 2711, 2780, 3404

Orange Blossom

White Orange Blossom tree with blue bird and butterflies .

2721, 2722, 2723, 2724, 2725

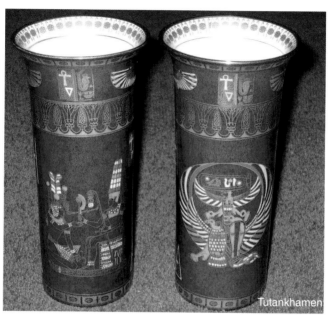

Tutankhamen

Blushware - Nasturtium

Colourful trailing flowers and leaves on blushware.

2749

61

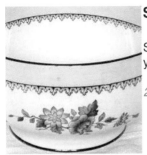

Spray of Flowers

Spray of flowers and decorative yellow borders on pale ground.

2779

Birds on Bough

Colourful birds with long feathery tails perched on a bough. The tree has blue, green and lilac foliage, also a pretty butterfly in flight.

2794, 3394

Gallant

Lady and Gallant Dandy rendezvous at the gazebo in the garden.

2804, 2839, 2863, 2867, 2869, 2872, 2893, 2953, 2954, 2956

New Mikado with Lady

Chinese figures, pagoda, bridge and trees. Sometimes has two cranes and punt like boat. Also with a moderne Lady raised as a lid decoration.

2814

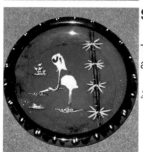

Stork and Bamboo

Two storks (one drinking) in pool amongst bamboo plants.

2822, 2932, 2933, 2934

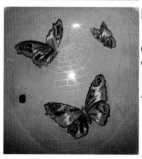

New Flies

Gossamer spiders web with various butterflies in flight.

2837, 3023, 3025

Pomander Pendant

Enamelled design in the shape of a pomander with tendrils.

2843

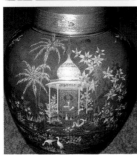

Persian

Persian design of figures in a temple, usually two white birds by water. Desert scene and palm trees. Persian back stamp.

2882, 2883, 2884, 3067, 3068, 3131

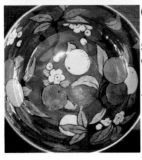

Orchard

Sprays of various orchard fruits with blossom and leaves.

2885, 2886, 3064

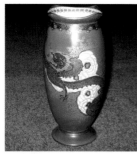

Dragon and Cloud

Oriental fiery dragon with long swirling body amongst stylised ornate clouds.

2887, 2903, 3237, 3331, 3332, 3333, 3351

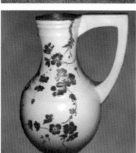

Trailing Blossom

Trailing sprays of blossom.

2896

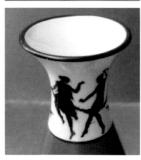

Dancers

Figures in silhouette dancing with pan pipes and small birds flying around.

2905

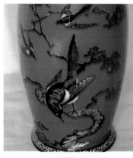

Magpies

Realistic Magpies perched on tree branches and sometimes also in flight.

2907, 2908, 2911, 2912, 2975, 2976

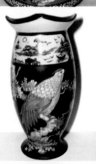

Cretonne

Exotic red crested bird perched on the branches of an oriental tree with colourful leaves and flowers.

2913

Fruit Branch

Realistic looking fruit and blossom on a branch.

2920

Sunrise

Pretty enamelled border design of petals and leaves. Matt black and orange lustre exterior.

2922

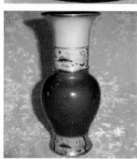

Mikado without Mikado

Mikado pattern number with a plain body. Also has a Temple pattern frieze. See page 43 for Mikado.

2927

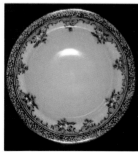

Scalloped Lace

Black frieze with ornate lace effect border on yellow ground.

2935

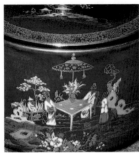

Chinese Tea Garden

Oriental scene of figures enjoying refreshments in a pagoda garden. Also has a variety of beautiful enamelled trees and flowers.

2936

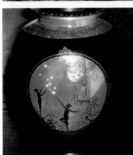

Moonlight Cameo

Medallion with figures playing with bubbles silhouetted in the moonlight.

2944, 2945, 2946, 2947, 2960, 2964, 2980, 3392

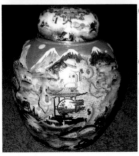

Chinaland

Elaborate and complex chinoiserie design. Pagodas, terraces, trees, figures and usually snow capped mountains and a golden sun.

2948, 2949, 2950, 3014, 3015, 3895

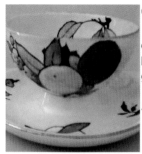

Citrus Fruit

Oranges and other fruit with blossom and leaves on a white ground.

2961

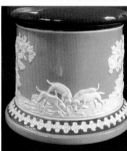

The Hunt

Hunting scene with hunting dogs and trees in raised relief as in Wedgwood.

2962

Meadow

Intricate and ornate gold border design.

2979, 3063, 3077, 3078

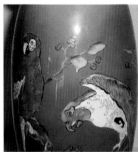

Parrots

Brightly coloured parrots perched on branches and pecking at berries. Also has an ornate coloured frieze.

3016, 3017, 3018, 3037, 3095

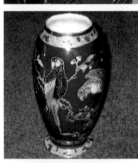

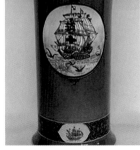

Galleon

Realistic scene of Galleon ship sailing on waves.

3020, 3753, 3953, 3957

Shagreen

Band of colour with gold speckles above plain ground.

3033, 3053, 3054, 3056, 3057, 3069

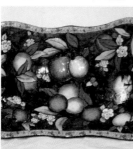

Orange Embossed

Oranges, fruit, leaves and blossom with ornate frieze.

3041, 3042, 3052

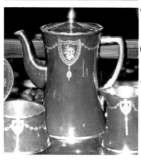

Violets

Ornate pendant design in gilt.

3043

Bird & Pine Cone

Colourful birds perched in pine trees amongst pine cones.

3046

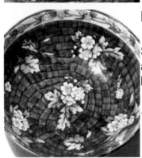

Mayflower

Sprigs of flower heads and foliage against a design of mosaic effect background.

3049

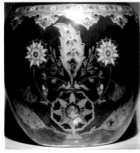

Turkish

Lavishly detailed enamelled flower design with detailed border.

3050, 3071, 3116

Persian Flowers

Persian stylised floral heads and leaves with ornate border.

3050

Swallow & Cloud

Swallow or swallows in flight amongst gold ornate stylised clouds.

3073, 3074, 3075, 3134, 3174, 3243

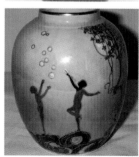

Moonlight

Figures playing with bubbles silhouetted in the moonlight.

3075, 3076, 3118

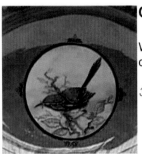

Cameo Wren

Wren perched on branch set in a cameo.

3115

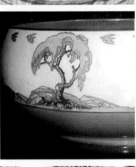

Landscape Tree

Blossom, birds and old gnarled tree with pendulous green foliage.

3141, 3142

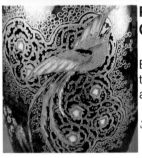

Paradise Bird & Tree with Cloud

Bird of Paradise with long plumed tail flying across stylised clouds and amongst oriental trees.

3143, 3144, 3154, 3252

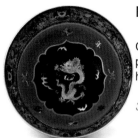

Dragon in Cartouche

Oriental fiery dragon in cartouche panel with oriental symbols. Also has a decorative frieze.

3145, 3146

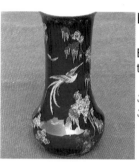

Paradise Bird & Tree

Bird of Paradise with long plumed tail flying amongst oriental trees.

3147, 3150, 3151, 3155, 3157, 3159, 3202, 3241, 3350

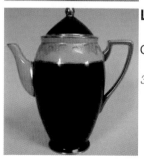

Lace Frieze

Ornate frieze like lace work in gilt.

3173

Mikado in Cartouche

Chinoiserie design of pagodas, bridges, oriental ladies and usually a pair of kissing birds in flight.

3178

Cubist Butterfly

Bold stylised flowers, berries and butterflies.

3190, 3194, 3195, 3223, 3233, 3469

Bird of Paradise

Bird of Paradise with long plumed tail flying amongst oriental trees .

3191, 4117, 4118, 4234

76

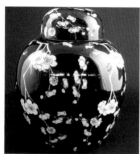

Prunus

Sprays of prunus blossom.

3193

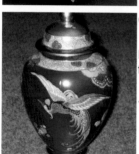

Chinese Bird

Exotic bird with long curly tail, flowers and stylised cloud motifs.

3196, 3197, 3296, 3527, 3544

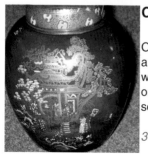

Chinese Figures

Oriental scene of figures depicting an Emperor leaving the Temple with servants in attendance. Also ornate enamelled trees and sometimes pagodas.

3199

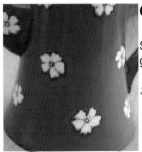

Corolla

Simplistic flower heads on a plain ground.

3226, 3227, 3228

Spots

Coloured spots on a plain ground.

3229, 3231, 3912, 3916, 4011, 4223, 4224, 4225, 4226, 4227, 4232, 4322, 4324, 4372, 4379, 4404, 4406, 4408, 4418, 4442, 4511

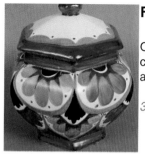

Floral Scallops

Overlapping scallop shapes containing five coloured petals of a flower, handcraft.

3234

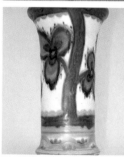

Shamrock

Three petalled large blue flowers, handcraft.

3235

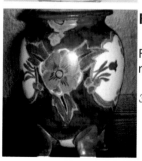

Floribunda

Flowers in orange, blue and mauve with leaves.

3236

Forest Tree

Exotic tree with slender trunk
rising to a wide pendulous canopy
of foliage.

*3238, 3239, 3240, 3244, 3244,
3248, 3250, 3253, 3254, 3265,
3283, 3648, 4426*

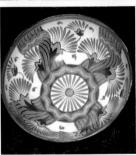

Flowering Papyrus

Geometric handcraft design with a
variety of shapes in blue, yellow
and mauve.

3242

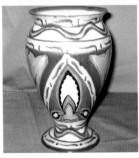

Orchid

Geometric floral design with
medallions containing Orchid like
flowers and shapes surrounded by
patterned borders. Handcraft.

3255, 3325

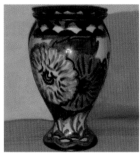

Marigold

Flower heads in blue, cream and mauve with large petals outlined in blue. Also has decorative borders. Handcraft.

3271

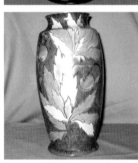

Cherry

Design of crude stems and leaves in autumn colours with yellow and red cherries.

3272, 3417

Delphinium

Blue delphinium flowers rising in spires and leaves. Handcraft.

3273, 3487, 3837

81

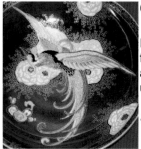

Chinese Bird & Cloud

Exotic bird with long curly tail in flight amongst small pretty flowers and stylised cloud motifs, also usually has a butterfly.

3274, 3275, 3327

Honesty

Stylised Honesty branches and seed pods.

3278

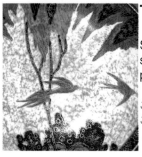

Tree & Swallow

Swallows flying past slender stemmed tree with wide canopy of pendulous foliage and flowers.

3279, 3280, 3281, 3283, 3285, 3384

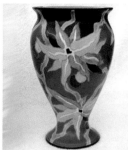

Stellata or Wild Cherry

Cherry blossom star shaped flowers with leaves and brightly coloured berries.

3291, 3326

Farrago

Design of various flowers and chevrons, geometric pattern.

3297

Zig Zag

Striking design of lightning like zig zag patterns.

3299, 3356, 3357

New Chinese Bird

Exotic bird with long tail in flight and looking back angrily. Also has some simplistic flowers and decorative borders.

3304

Carnival

Brightly coloured geometric design of stylised flowers, leaves and shapes also has a butterfly.

3305

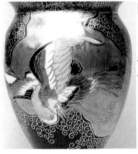

New Chinese Bird & Cloud

Exotic bird in flight looking back angrily, flying past stylised clouds and large stylised flower heads.

3320, 3321, 3322

Pomona

Citrus type fruit and leaves on dappled effect pattern.

3324, 3328

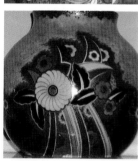

Sunflower Geometric

Sprays of stylised geometric leaves and small flowers. Also has sunflower heads.

3334, 3339

Jazz

Geometric design with brightly coloured lightning flashes, bands of detail and small bubbles rising.

3352, 3353, 3361

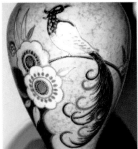

Feathertailed Bird and Flower

Bird of paradise with crest and long feathered tail, perched on a stylised blossom bough with large flower heads.

3354, 3355

Gentian

Large flower heads with blue petals and black stamens. Handcraft.

3358

Stag

Realistic Stag like animal leaping in front of the sun amongst a barren desert landscape scene.

3359

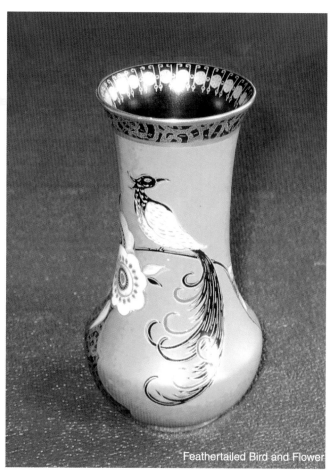

Feathertailed Bird and Flower

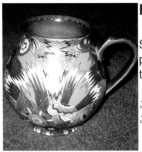

Floral Comets

Stylised flower heads amongst a profusion of triple banded comets' tails.

3385, 3387, 3401, 3405, 3422, 3428

Fantasia

Exotic bird with outstretched wings and swallow like tail, amongst exotic flowers and foliage in fantasy garden scene.

3388, 3389, 3400, 3406, 3421, 3427

Garden

Profusion of brightly coloured daisy like flowers rising in spires.

3390, 3396, 3413, 3433, 3438, 3471, 3474, 3476, 3477, 3478, 3501, 3581, 3609

Rudolf's Posy

Design of flower heads, large and small with patterns of leaves.

3408

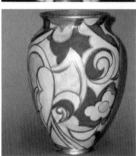

Scroll

Swirling design of scroll patterns, shapes and curves.

3411

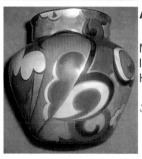

Aurora

Multi-coloured bold, bulbous cloud like shapes outlined in gilt. Handcraft.

3412

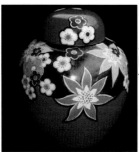

Lazy - Daisy

Simple primula shaped flower heads and large star shaped flower heads in bright colours.

3414

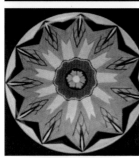

Sagitta

Cloud shaped flowers and blue stylised trees with v-shaped leaves.

3415

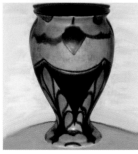

Arrowhead

Abstract design of feathery leaves and large flower heads.

3416

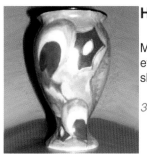

Holly

Multi colour (orange and brown etc) abstract design of various shapes.

3418

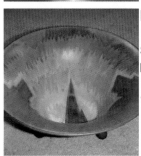

Metropolis

Stylised city skyline with mauve, pink and yellow aurora shading.

3420

Parkland

Bold simple tree with enamelled dense foliage of autumn colours.

3423, 3523, 3524

Prickly Pansy

Stylised landscape design of tall trees with pendulous foliage. Also has large pansy like flowers with spiky leaves in a matt finish.

3424, 3449, 3455, 3499

Jigsaw

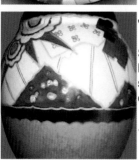

Stylised flower heads with pointed leaves and a patchwork of various shapes some containing decorative patterns.

3431

Jaggered Bouquet

Bouquet of ornate stylised flowers with striking and jagged leaves.

3439, 3457, 3489

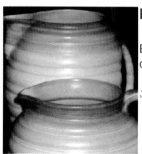

Neapolitan

Bands of colours encircling the design with a ribbed finish.

3445, 3841, 3842

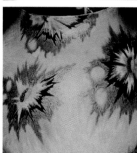

Explosion

Extravagant starburst design in blue, black, silver and gold.

3447, 3454

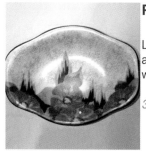

Peach Melba

Large orange flower heads arranged in overlapping groups with blue and green foliage.

3448

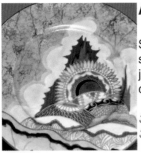

Awakening

Stylised sunrise design. Ornate sun rising amongst clouds with jagged and ornately decorated centres.

3450, 3452, 3453, 3456, 3494, 3496, 3497

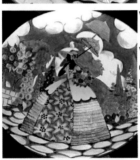

Victorian Lady

Victorian lady dressed in decorative crinoline dress and parasol walking in a pretty garden.

3451, 3491

Explosion & Butterfly

Star shaped colourful exploding flower heads and a butterfly.

3452

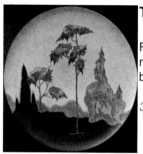

Towering Castle

Fantasy Castle with tall trees and rocks in the foreground in white, brown, blue, and yellow colours.

3458

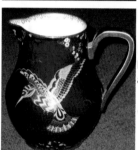

Humming Bird

Elaborately decorated exotic humming bird hovering amongst a floral decoration with enamels.

3462

Iris

Simplistic design of large Iris like flowers and leaves.

3498

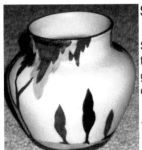

Sylvan Glade

Simple conifer like trees and a tall tree with pendulous foliage in glade design, red border to edge of piece.

3500

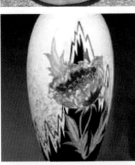

Jazz Poppy

Pendant of poppy like flowers and foliage against a dark jaggered backdrop. Handcraft.

3503

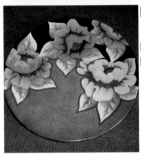

Rose Marie

Design of large flower heads and leaves in enamels.

3504

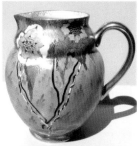

Magical Tree (Rosetta)

Design of stylised trees with spangled trunk and large colourful flower heads by a lily pond.

3505

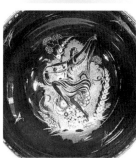

Gypsy

Lady dancing in flamboyant, swirling Gypsy style.

3506

Iceland Poppy

Design of large colourful poppies, ornamental grasses and leaves.

3507, 3646, 4192, 4193, 4194, 4220, 4221, 4228

Wind & Flower

Large stylised flowers in variety of bright colours on slender stems appearing to wave in the wind. Handcraft.

3508

Ensign

Colourful and ornately decorated border design of enamels and small flower heads.

3510

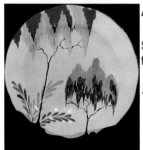

Autumn Trees & Ferns

Stylised trees with pendulous foliage and ferns in bright colours.

3517

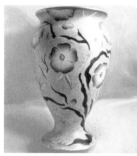

Apple Blossom

Black and grey twisting branches
with pink apple blossom like
flowers. Handcraft.

3522

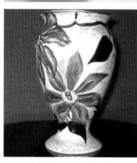

Clematis

Large multi-coloured Clematis
flower heads overlapping also has
some black leaves.
Handcraft.

3525, 3545

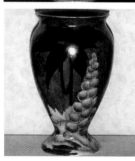

New Delphinium

Spires of Delphiniums in blue and
pink. Also has a black shadowy
tree in the background.

3526

Oranges

Oranges and leaves attached to a branch on black ground.

3528

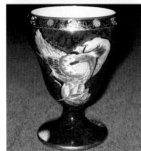

Crested Bird & Water Lily

Exotic oriental crested bird perched on a water lily.

3529, 3530, 3536

Bookends - Fan or Asymmetric Flower

Bookends with colourful fan shape or flower heads.

3532, 3533, 3535

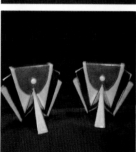

Bookends - Saddleback

Bookends in Saddleback design.

3537

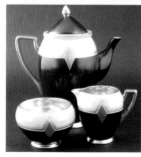

Diamond

Diamond shape and design in gilt.

3546, 3547, 3550, 3678

Eclipse

Geometric design in vivid colours.

3551

Deco Fan

Brightly coloured fan design with pink rim and border.

3552

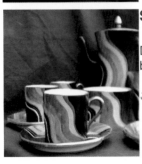

Strata

Diagonal wavy stripes in gilt, beige, green and white.

3553

102

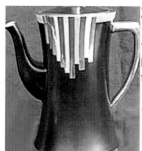

Ziggarette

Vertical stripes of green yellow blue and gold descending from top rim

3554

Entangled Droplets

Brightly coloured enamelled beads tangled in web like design.

3555

Fan

Fan of brightly coloured and ornately decorated panels. With clouds of enamelled beads ascending above exotic circular flower heads.

3557, 3558

Nightingale

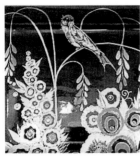

Singing Nightingale bird perched on a stem with a variety of colourful stylised flowers.

3562, 3598

Tree & Cottage

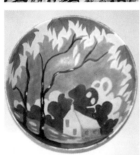

Simple cottage design with a smoking chimney nestled in a glade beneath large stylised trees.

3563

Fairy Shadow

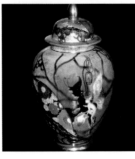

Motif of Fairy with delicate wings playing and casting shadows amongst trees. Also bands containing colourful and ornately decorated flower heads.

3564, 3576

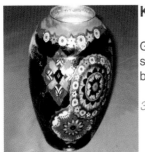

Kaleidoscopic

Geometric shapes of patterns, stars and circles in profusion of brightly coloured enamels.

3565

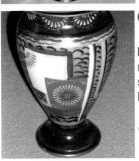

Geometrica

Modern Art design with geometric right-angle shapes, overlapping squares and patterns with wavy lines.

3566

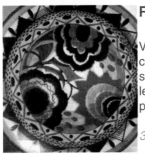

Russian

Vibrant pattern of concentric circles in many colours. Stylised sun and bands of colour with leaves. Border has geometric pattern like saw teeth.

3567

Nightingale Garden

Large stylised brightly coloured flower heads.

3568

Green Trees

Trees with rambling branches and spiky foliage in varying shades of green.

3569

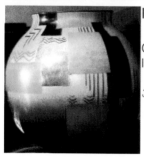

Mondrian

Coloured squares, chevrons and lines in geometric design.

3570

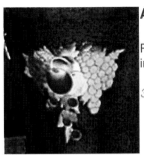

Apples & Grapes

Realistic assortment of fruit including apples and grapes.

3571

Medley

Bands of bright colours, blue, green, yellow, orange, red and purple.

3587, 3591, 3593, 3599, 3600, 3845

Flower Medley

Bands of bright colours, blue, green, yellow, orange, red and purple plus a simplistic pattern of shapes.

3588, 3596

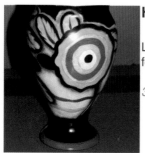

Hiawatha

Large simplistic flower heads and feathers in bold bright colours.

3589, 3590

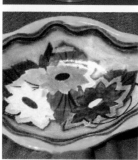

Gazania

Large simplistic brightly coloured flower heads and leaves.

3592

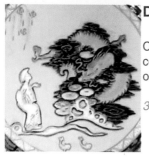

Dragon & Traveller

Chinese Dragon menacingly confronting a traveller dressed in oriental style.

3594, 3595, 3597, 3656, 3660

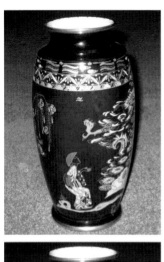
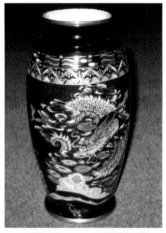
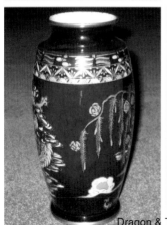
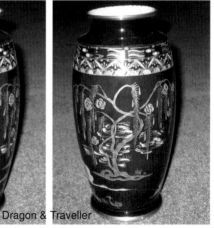

Dragon & Traveller

Melange

Large stylised flower heads ornately and colourfully decorated with patterns also has leaves.

3601

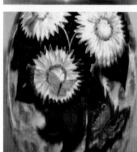

Dahlia & Butterfly

Large bright yellow flower heads and butterflies.

3606

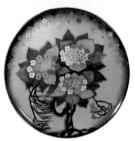

Lace Cap Hydrangea

Decorative Lace type design with Hydrangea flower heads and leaves.

3639, 3966, 3967, 3969

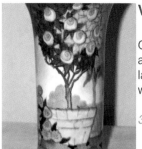

Victorian Garden

Garden scene of colourful shrubs and flowers, similar to "Crinoline lady with parasol in garden" but without the lady.

3643

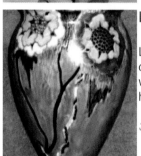

Rosetta

Large stylised flowers with bright colourful patterns growing in trees with black and white bark and hanging foliage.

3645

Sylvan

Stippled painted effect merging into one another in two colours.

3650, 3715, 3718

Scimitar

Geometric design of arches, bands and semi-circular shapes containing colourful patterns and flowers in enamels on dappled background.

3651, 3652

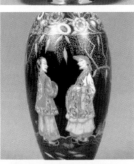

Mandarins Chatting

Two Chinese figures chatting under a Mandarin tree with beautiful coloured enamels and flowers. Sometimes has a second tree with detailed foliage and spiky leaves.

3653, 3654, 3672, 3675, 3680

Jazz Stitch

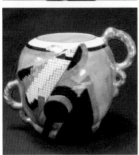

Geometric design of shapes some containing a stitch effect pattern in orange, black and yellow.

3655

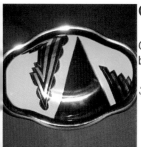

Chevrons

Geometric design in a colour plus black and silver.

3657, 3671

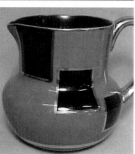

Carre

Abstract design of black squares with silver borders.

3658, 3659

Norwegian Flowers

Simplistic flowers with a variety of flower heads growing from a green base.

3661

Liberty Stripe

Horizontal encircling lines in
mauve, grey and pale blue
separated by gold band.

3662

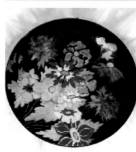

Summer Medley

Profusion of brightly coloured
summer flowers in a variety of
designs, some with spiky petals.
Handcraft.

3663

Norwegian Miss

Girl dressed in Norwegian style
surrounded by colourful flowers.

3668

Candy Flowers

Posy of a anemone type flower heads with bands of patterns.

3669

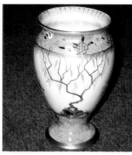

Mandarin Tree

Mandarin tree with beautifully ornate coloured enamels and flowers. Usually has second tree with detailed foliage and spiky leaves.

3672, 3702, 3703, 3719

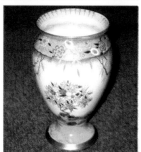

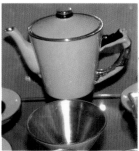

Bathing Belle

Handle formed as a beautiful lady with long dark tresses, posing provocatively with arched body in sumptuous gilded robe.

3681, 3684, 3796

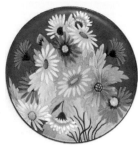

Daisy

Profusion of daisy flowers in bright colours.

3691, 3693, 3714

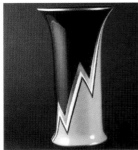

Lightning

Lightning flashes of zig zag lines.

3692, 3716

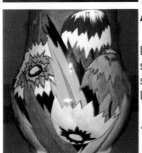

Anemone

Large bold brightly coloured stylised flower heads with spiky shaped petals and jaggered leaves.

3694

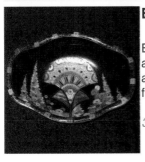

Egyptian Fan

Elaborate geometric patterns arranged in a fan shape design and brightly coloured enamelled flowers, some rising in spires.

3695, 3696, 3697, 3698

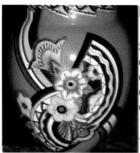

Rainbow Fans

Semi circular open fan shapes containing wavy patterns and exotic flower heads. Also bands of colours like a rainbow and an ornate frieze.

3699, 3700, 3713, 3721

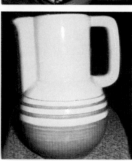

Bands

Two tone green bands.

3720

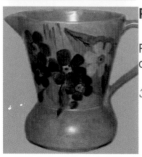

Primula

Primula flower heads in a variety of colours with leaves.

3742, 3745, 3746

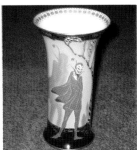

Red Devil (Mephistopheles)

Red devil and shadow beneath a spangled tree with pendant foliage and blossom like eye motifs. Large brightly coloured exotic flowers with spear shaped leaves.

3765, 3767, 3769

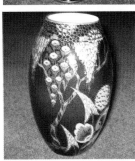

Devil's Copse

Mottled exotic tree with ornate pendant foliage and blossom like eye motifs. Large coloured exotic flowers with spear shaped leaves.

3765, 3769, 3787, 3809, 3817, 3859

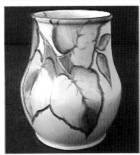

Autumn Leaf

Spray of leaves in Autumn hues of pink, green and orange.

3766

119

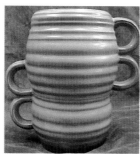

Ribbed Stoneware

Ribbed vase.

3770, 3775, 3776, 3777, 3778,
3779, 3780, 3781, 3782, 3784,
3793, 3804, 3829, 3830, 3847,
3877, 3878, 3879, 3896, 3904

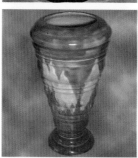

Dripware

Running paint pattern in a variety
of colours.

3771, 3772, 3773, 3917

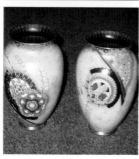

Bell

Stylised flower heads in brightly
coloured enamels and patterns,
some contain harebell flower
heads. Detailed lace like
triangular panels of pretty ornate
flowers.
3774, 3785, 3786, 3788, 3792

120

Gum Tree

Flowers, spiky leaves and nut like seed pods hanging from a tree.

3789, 3790, 3794

Gilt Scallop

Rouge and black with ornate border of scalloped edging in gilt with enamelled droplets.

3795

Herbaceous Border

Spires of hollyhocks, foxgloves and pansy like flowers in a flowerbed.

3801

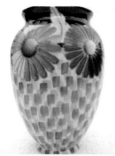

Autumn Daisy

Bold Daisy flower heads and leaves amongst a dappled pattern of brushstrokes.

3802

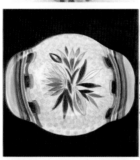

Modern Crocus

Medley of brightly coloured bands and black border. Flower heads of slender crocus shaped petals arranged in a circle with coloured leaves.

3803

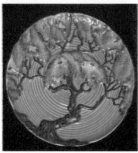

Oak Tree

Oak Tree with old gnarled trunk and autumn foliage on ribbed concentric circles.

3810, 3811

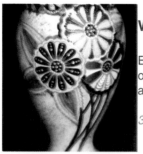

Wagon Wheels

Exotic circular flower heads ornately decorated with enamels and leaves on stems.

3812, 3813, 3814

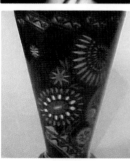

Needlepoint

Flower heads enamelled in embroidery like patterns. Bands and crescents of enamelled colours like lace.

3815, 3816

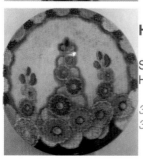

Hollyhocks

Spires of brightly coloured Hollyhocks.

3818, 3819, 3820, 3827, 3854, 3972, 3973

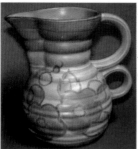

Autumn Breeze

Stoneware design, simplistic flowers heads and bands of colours.

3839, 3840

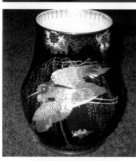

Sketching Bird

Exotic tree with pendant hanging foliage and decoratively enamelled kingfisher like bird in flight.

3852, 3889, 3890, 3891, 3907, 3951, 3952, 4211, 4393

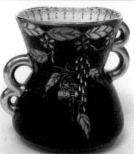

Leaf

Design of leaves and small flower heads decorated in enamels.

3857, 3861, 3873

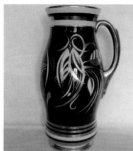

Tendrillon

Design of swirling patterns with leaves and tendrils in white and gilt.

3858

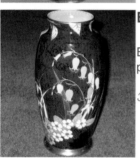

Bluebells

Bluebell flowers with snowdrops, primulas and autumn leaves.

3862, 3872, 3874, 3875

Garden Gate

Deco tree, bushes and flowers with path leading to garden gate.

3863

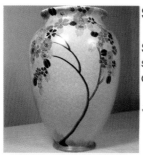

Spring

Spring flowers depicted on a tall slender tree in many bright colours, handcraft.

3865, 3897

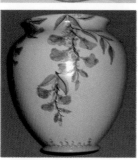

Wisteria

Wisteria like flowers trailing from tree with leaves.

3866

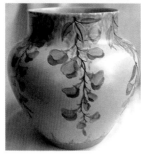

New Laburnum

Laburnum like flowers trailing from tree with leaves.

3867

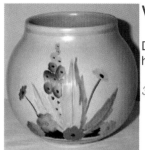

Vogue

Design of simple primula and hydrangea flowers.

3868

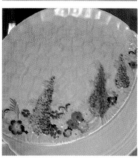

Rock Garden

Simple embossed primula like flowers heads and spires of flowers against a background of stone shaped patterns.

3876

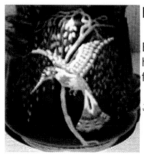

Humming Bird with Tree

Elaborately decorated exotic bird hovering under weeping tree with floral decoration.

3884, 4355

127

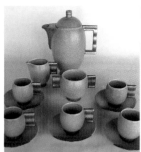

Moderne

Moderne set.

3886, 3887, 3888

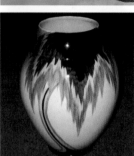

Sketching Bird with no Bird

Exotic tree with spiky pendulous foliage. No bird and no flowers.

3891

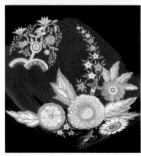

Persian Garden

Sprays of exotic enamel flowers and foliage, some in spires with star like heads. Sometimes a magical tree with a variety of flower heads.

3892, 3893, 3894

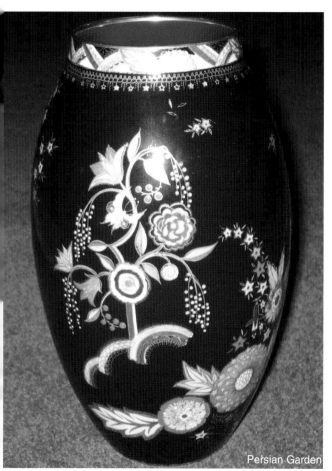

Persian Garden

129

Incised Square

Incised geometric simplistic flower patterns, some flower heads are square shaped. Also has some wavy lines.

3900

Incised Diamond

Incised geometric simplistic flower patterns, some flower heads are diamond shaped. Also has some wavy lines.

3901, 3905

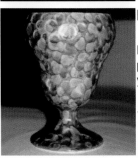

Hammered Pewter

Dimpled effect like hammered pewter in turquoise, green and yellow.

3902

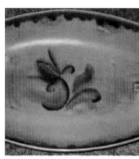

Floral Mist

Floral wispy flower design in blue, yellow and green.

3913

Mirage

Simplistic abstract pattern.

3915

Leaf and Catkin

Leaf and Catkin.

3918, 3919

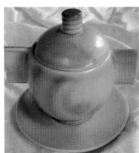

Old Stoneware

Old Stoneware effect with splashes of blue and brown.

3920

Wild Duck

Realistic Duck with shadow in flight over wild grasses and shrubs.

3922, 3923, 3924, 3927, 4042

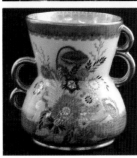

Summer Flowers

Array of summer flowers and leaves.

3925, 3926, 3927

Will o'Wisp

Wavy pattern in mauve with wisps of paint in pale green and brown.

3929, 3939

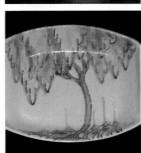

Tubeline Tree

Tubelined tree with hanging foliage in yellow, mauve and green.

3943, 3944

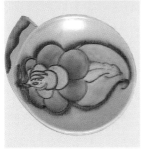

Tubelined Flower

Tubelined flower in blue and green with thistle like flower in yellow.

3945

Hazelnut

Hazelnuts and leaves.

3946

Flower & Falling Leaf

Exotic complex geometric flower heads with leaves swirling above and then falling over.

3948, 3949, 3950, 3952

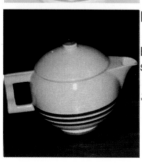

Rayure

Black circular stripes on Moderne shape.

3955

Blossom

Small enamelled blossom like flowers.

3958

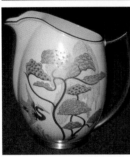

Heron & Magical Tree

Heron flying past large ornamental tree.

3965, 4108, 4150, 4153, 4159, 4160, 4293, 4313, 4325, 4326, 4332

Blossom & Spray

Blossom spray and small enamelled flower heads with gilt leaves.

3968, 4047

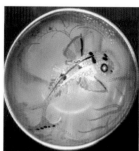

Shabunkin

Ornamental colourful enamelled fish with flowing fins amongst exotic seabed plants.

3970, 3971

Tubelined Poppy & Bell

Tubelined poppies and bell flowers on slender stems.

3974

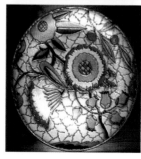

Persian Rose

Gilt tubelining of exotic flower heads and bell flowers with leaves.

3975

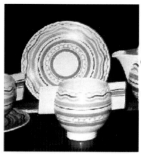

Banded and Crosstitch

Moderne design with bands of circles and wavy patterns.

3976

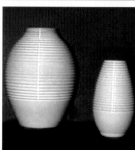

Engine Turned Ware

Ribbed style.

3977, 3978, 3979, 3980, 3981, 3982, 3999

Sunflower

Large Sunflower heads and leaves.

3982, 3996

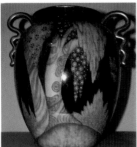

Eden (Tiger Tree)

Exotic tree with gnarled trunk and lobes and pendulous hanging foliage with pretty flowers. The foliage also rises from the base in spires.

3989, 4241, 4242

Buttercup

Design in shape of Buttercup in embossed style. In yellow or pink.

3993, 3994

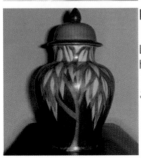

Forest Night

Large trees with pendulous hanging foliage of pointed leaves.

3997

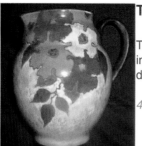

Tubelined Marigold

Tubular raised edge flower heads in red, orange and green with dark leaves.

4012

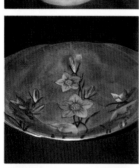

Harebells

Harebell flowers edged with gilt.

4015, 4016, 4136, 4154

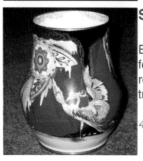

Secretary Bird

Exotic bird with fan shaped tail feathers and long legs similar to a road runner, beneath a decorative tree in enamels.

4017, 4018, 4106, 4107

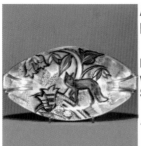

Animal (Squirrel, Deer or Fox)

Decorative landscape with woodland animals either a Squirrel, Deer or Fox.

4019

Leaves

Design of pale coloured leaves.

4040

Tyrolean Bands

Multi-coloured circular bands in various sizes and wavy lines.

4076

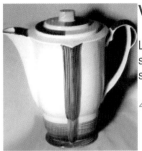

Vertical Stripes

Large vertical stripes and sometimes smaller horizontal stripes on base in gilt.

4077, 4079, 4080, 4083, 4084

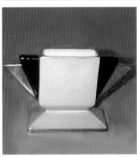

Beanstalk

Plant with large leaves like a beanstalk.

4081

Heatwave

Diagonal bands of colours in orange and yellow and many fine wavy lines.

4092

Spider Web

Cobwebs nestled among fruiting berries on branch, also flowers (harebells) and dragonflies.

4103, 4242, 4243, 4244, 4252, 4254, 4259, 4327, 4330, 4331, 4347, 4366, 4399, 4420, 4439, 4509

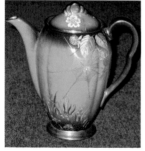

Black Crow

Colourful scene with black crows.

4105

Primula and Leaf

Primula flowers in bright colours in a flower bed and a butterfly in flight.

4119, 4120, 4121

Butterfly

Colourful Butterfly in flight among grasses.

4122, 4123

143

Babylon

Profusion of foliage and leaves cascading down with pretty bell and star flowers. Large star shaped flower heads ornately decorated in enamels.

4125, 4126, 4137, 4158, 4168, 4189

Banded

Circles.

4128, 4130

Tubelined Fields and Trees

Tubelined landscape scene with curving fields and bulbous trees and hills.

4138

144

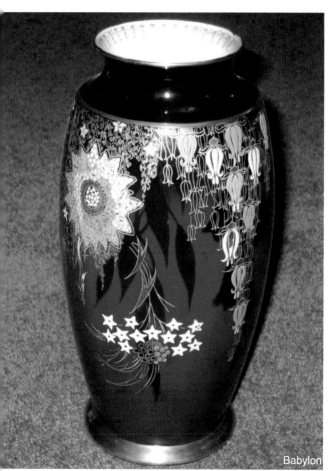

Babylon

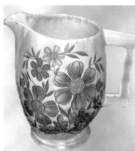

Daisies

Large and small blue flower head and leaves.

4139

Azalea

Large design of Azalea flower heads with stamens.

4140

Plain with Leaves

Plain colour with sprigs of white leaves.

4157

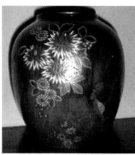

Fighting Cocks

Two cockerels displaying in the fighting position amongst a beautiful array of flowers.

4161, 4186, 4199, 4380, 4401, 4417, 4422

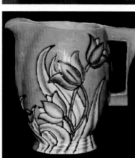

Tubelined Tulip

Tubelined Tulip flowers on stems with leaves.

4162

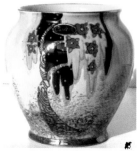

Spangle Tree or Tiger Tree

Stylised tree with old gnarled trunk and black shadow. Also has hanging green foliage with small flower heads.

4163

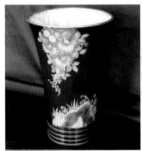

Fighting Glade

Display of flower heads and leaves similar to "fighting cocks" but does not have the cockerels displaying.

4184, 4198, 4212, 4377

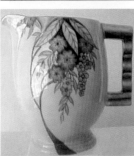

Pastoral

Slender tree with orange and blue flower heads also has small and large leaves.

4185

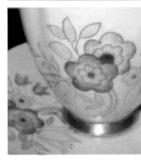

Cinquefoil

Yellow and purple flowers, green foliage.

4191, 4192

148

New Anemone

Anemone flowers in bright colours
and leaves.

4213, 4219, 4231, 4245

Starflower

Flowers with geometric spires like
stars and smaller flowers like
stars cascading down.

4215, 4216

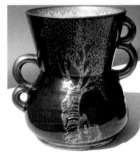

Tree & Clouds

Stylised tree with gnarled trunk
and pendulous foliage trailing
down and clouds in the
background.

4217, 4292

Leaf & Dots

Design of dots and sprays of leaves.

4218

Daydream

Large flower heads and leaves in blue also has a frieze of blue scrolls. Handcraft.

4246

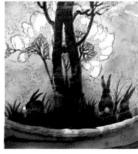

Rabbits at Dusk

Rabbits feeding amongst grasses shown in silhouette, under tall trees with green foliage.

4247, 4249, 4257

Eden Canopy

Pendulous ornate foliage with pretty flowers from an exotic tree. Also has butterflies fluttering by.
4248, 4249

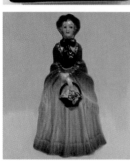

Figurine

Carlton China Figurines. Monica, Curtsy, Nan, Nell, Peggy, Joan, Grandma, Jean.

4260, 4262, 4264, 4268, 4269, 4270, 4273, 4275, 4276, 4314

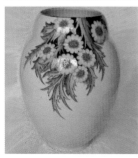

Marguerite Daisy

Yellow daisy like flowers with green serrated leaves like nettle leaves.

4277

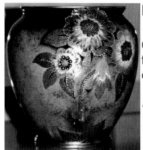

Palm Blossom

Ornately enamelled and detailed flower heads and leaves growing on slender stem.

4278, 4297, 4298

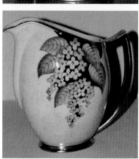

Lilac

Realistic Lilac flowers and leaves hanging as from a branch.

4279, 4310

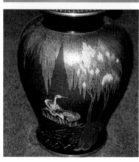

New Storks

Two crane like birds wading in a lake under trees with pendulous spiky foliage.

4280, 4283, 4339, 4340, 4342, 4343, 4344, 4348, 4367, 4400, 4421, 4443, 4507

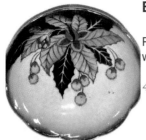

Beech Nut

Posy of leaves in autumn colours with maturing nuts.

4281, 4282

Silk Sands

Contour lines as in a silk pattern or left by the sea on the sands.

4286, 4287, 4289

Contours

Design of "dashes" as in broken lines also is edged in gilt.

4291

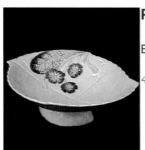

Primula Embossed

Embossed primula flower design.

4368, 4369

Snowdrops

Snowdrops flowers and shadows with leaves.

4375

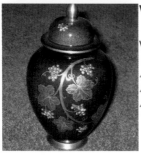

Vine

Vine with leaves and grapes.

4385, 4387, 4395, 4402, 4405, 4411, 4423, 4441, 4444, 4480, 4481, 4512

Poppy & Daisy Embossed

Embossed poppies and daisies.

4388, 4389

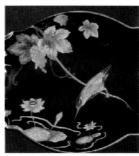

Kingfisher & Water Lily

Kingfisher perched on the stem of a climbing plant over water lilies.

4391, 4491, 4560, 4561, 4562, 4580, 4603, 4606

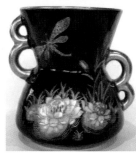

Water Lily

Water Lily with bulrushes and a dragonfly.

4435, 4436, 4492, 4563, 4564, 4565, 4566, 4604

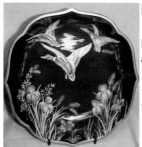

Duck

Realistic Mallard type ducks flying above irises and wild grasses.

4455, 4459, 4490, 4499, 4500, 4501, 4502, 4503, 4605, 4608

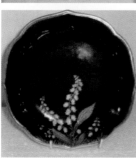

Lily of the Valley

Lily of the Valley flowers and leaves.

4457, 4458, 4488

Stars

Gold stars.

4475

Crepes

Speckled blue with gold frieze design.

4515

Crocus

Crocuses.

4526

Coral

Fish swimming amongst coral.

4539

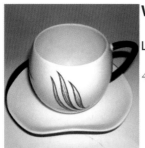

Windswept

Leaf design.

4581, 4582, 4583, 4622

Eastern Splendour

Figure in turban with castle and or slave under tree with hanging foliage.

4641, 4642, 4643, 4644, 4645, 4646, 4647, 4648

Imari

Aztec like symmetric design in blue and red on white. Carlton Ware China back stamp.

4658

Bamboo

Bamboo and hanging foliage.

4676, 4769

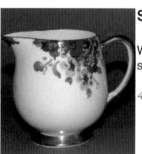

Sunshine

White gloss ground with groups of small flowers. Carlton China.

4693

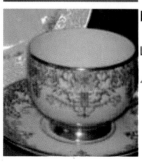

Lace

Lace pattern on white ground.

4723

Pearl Insignia

Symmetric design of circles
(beads), curved triangles and
flower heads.

4734

Springtime

Garden flowers and bluebirds on
pale ground. Carlton China.

4754

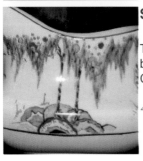

Strawberry Tree

Tree with pendulous foliage
bearing strawberry like fruit.
Carlton China.

4763

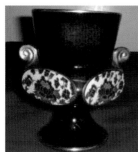

Plain with Floral

Floral patterns on white insets on blue with gold highlights.

4783

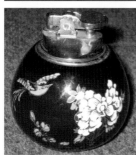

New Bird of Paradise

Birds of paradise in flight with buds, blossom, and butterflies.

4794, 4795

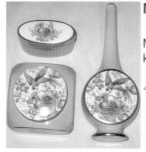

Malvern

Medallion with bird and fruit. Also known as "Fruit and Bird".

4801, 4909

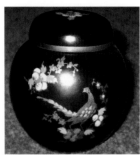

Pheasant

Pheasant like bird and flowers with gilt and enamels.

4805, 4934, 4935

Thistle Heads

Thistle heads.

4808, 4809

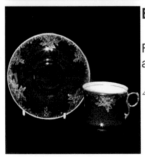

Enamelled Berries

Floral berry design in enamels and gilt. Carlton China.

4821, 4886

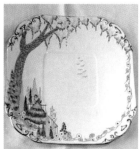

Afternoon Stroll

Lady strolling among pretty flowers and shrubs beneath a large tree with pendulous foliage. Carlton China.

4878

New Garden

Spires of daisy like flowers in many colours. Carlton China.

4880

Fantail Birds on Branch

Colourful Fantail birds perched on the branch of a tree. Carlton China.

4900

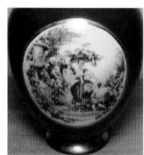

Enchantment Medallion

Medallions of couples in romantic garden scenes.

4907, 4908

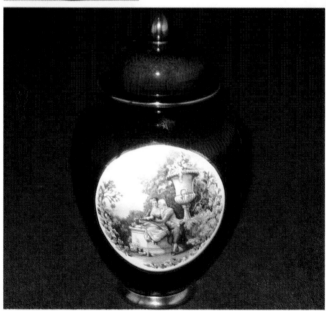

Starburst Tree & Birds

Birds perched on stylised trees with star shaped flowers. Carlton China.

4907

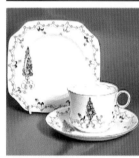

Spring Flower

Floral design with a decorative tree. Carlton China.

4908

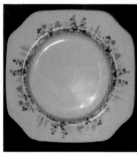

Floral

Floral decorations.

4911

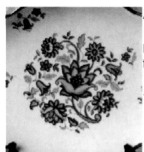

Aquilegia

Flowers, including Aquilegia type flowers.

4923

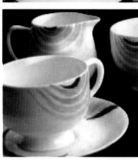

Rainbow

Deco rainbow like pattern. Carlton China.

4940, 4943

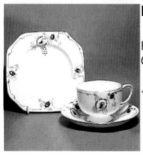

Bud Eye

Floral display with buds. Carlton China.

4942

Garden of Tranquillity

Oriental garden scene with two figures, one reclining beneath an ornate tree with large flower heads.

4947

Poppy

Realistic Poppies with long trailing stems and leaves. Carlton China.

4977

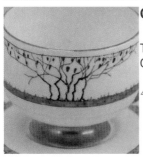

Orange Tree

Tree with orange coloured fruit. Carlton China.

4979

Autumn Trees

Trees with dark pendulous foliage.
Carlton China.

4986

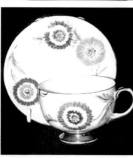

Bright Daisy

Colourful daisies like flowers and
sprigs of leaves. Carlton China.

4990

Sweet Pea

Sweet Pea flowers on stems.
Carlton China.

4992

Birds and Trees

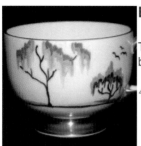

Tall trees with hanging foliage and birds in flight in the far distance.

4998

Glade

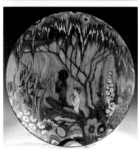

Pan like figure playing pipes beneath a tall tree and amongst exotic spires of flowers in shadowy forest glade.

number unknown

Heinz

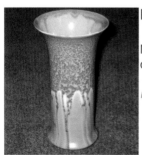

Mottled orange colour running down over green ground.

number unknown

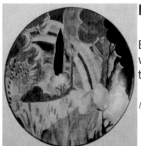

New Rainbow

Brightly coloured trees and foliage with a rainbow cascading through the centre of the design.

number unknown

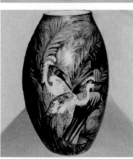

Rain Forest

Crane like birds wading through an exotic Rain Forest.

number unknown

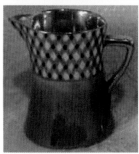

Hatching

Hatched trellis like pattern.

number unknown

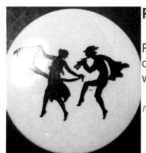

Pied Piper

Pied piper playing pipes and lady dancing, silhouetted on black and white.

number unknown

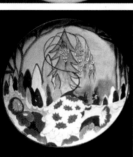

Fairy Dell

Enchanted forest scene with trees and flowers

number unknown

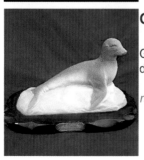

Glacielle Ware

Glacielle Ware comes in various designs of animals and birds.

number unknown

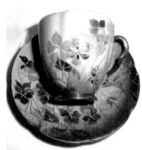

New Violets

Profusion of pretty violets and leaves.

number unknown

Denim

Male and female dressed in matching blue denim jeans and striped shirts.

number unknown

Plain with Lady

Plain blue lustre ground with a moderne Lady.

number unknown

Carlton Ware Shapes

This part of the book provides an identification guide to Carlton Ware by shape or impressed numbers.

With some impressed numbers there were a large number of different patterns that were applied. We are mainly looking at the ones where the impressed numbers more or less identifies the pattern (for example with the embossed floral range).

We have not shown all the different shapes with a pattern but an indication of the "pattern". This book essentially ignores the colours and the shape for identification and we usually show one piece of Carlton Ware from the many different ones.

A list of some of the different shape numbers are listed next to the picture. You can always look at our web site www.carltonware.com for more pictures classified by shape number. An index of Shape or Impressed numbers and the page on which a picture of that pattern may be found is included towards the end of this book.

The pictures have been listed historically, approximately. The older patterns are towards the beginning and the newer ones towards the end.

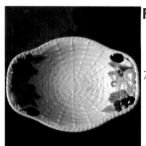

Fruit Basket

760, 830, 876

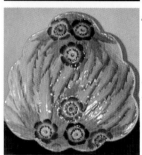

Anemone

*928, 932, 933, 935, 946, 975,
976, 978, 983, 1014, 1026, 1027,
1028, 1033, 1037, 1086, 1096,
1097, 1753, 3027, 3030*

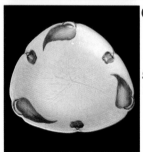

Gum Nut

*949, 950, 952, 1009, 1011, 1038,
1045, 1066*

Crinoline Lady

1012, 1705

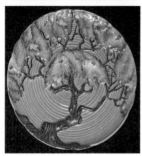

Oak Tree

*1098, 1143, 1144, 1145, 1146,
1147, 1148, 1149, 1155, 1162,
1163, 1164, 1165, 1166, 1167,
1168, 1169, 1175, 1183, 1185,
1186, 1187, 1188, 1189, 1190,
1191, 1192, 1193, 1194, 1208,
1214*

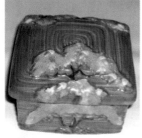

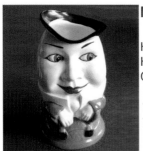

Musical Jug

Humpty Dumpty, Hunting Scene, Hangman, Flowers, Grandfather Clock.

1213, 1260, 1284, 1289, 1543, 1685

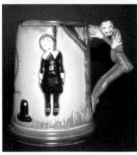

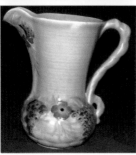

Rock Garden

1237, 1238, 1239, 1240, 1241, 1243, 1244, 1247, 1249, 1250, 1252, 1264, 1267, 1287

Blackberry/Raspberry

*1266, 1473, 1477, 1515, 1516,
1545, 1546, 1547, 1548, 1559,
1560, 1564, 1565, 1570, 1580,
1581, 1584, 1586, 1593, 1598,
1599, 1602, 1662*

Curled Lettuce

*1332, 1367, 1372, 1374, 1375,
1382, 1385, 1386, 1389, 1390,
1412*

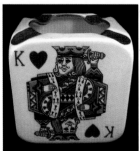

Card Series

Ashtray, Butter Dish.

1387, 2256, 2266

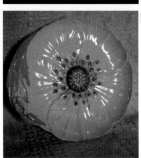

Buttercup

*1395, 1396, 1482, 1483, 1489,
1510, 1512, 1513, 1514, 1522,
1523, 1524, 1529, 1530, 1531,
1574, 1585, 1612*

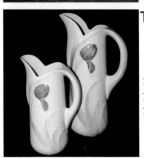

Tulip

*1404, 1416, 1417, 1418, 1419,
1420, 1421, 1422, 1439, 1453,
1457, 1459, 1461, 1736, 1811*

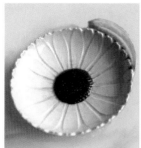

Daisy

1472, 1672, 1947, 1951

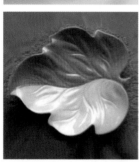

Leaf

*1539, 1772, 2361, 2363, 2367,
2368, 2369, 2371, 2372, 2373,
2377, 2381, 2383, 2386, 2388,
2389, 2417, 2888*

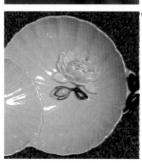

Water Lily

*1540, 1588, 1713, 1718, 1731,
1738, 1741, 1750, 1773, 1774,
1776, 1777, 1778, 1779, 1780,
1783, 1784, 1786, 1787, 1788,
1805, 1821, 1829*

Wild Rose

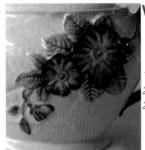

1551, 2100, 2108, 2114, 2115, 2116, 2117, 2118, 2120, 2121, 2122, 2123, 2124, 2132

Crocus

1552, 1747, 1763, 1765, 1766, 1809, 1818, 1832

Thistle

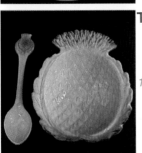

1576

Red Currant

1603, 1607, 1608, 1637, 1656, 1659, 1666, 1679

Apple Blossom

1614, 1617, 1618, 1621, 1627, 1638, 1648, 1649, 1650, 1651, 1652, 1653, 1654, 1655, 1663, 1664, 1665, 1668, 1669, 1670, 1671, 1678, 1680, 1686, 1687, 1688, 1689, 1696, 1697, 1700, 1701, 1704, 1707, 1710, 1714, 1720, 1723, 1728, 1729, 1756, 1799, 2008

Basket

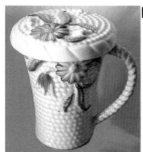

*1640, 1775, 1803, 1810, 1876,
1907, 1908, 1911, 1912, 1913,
1922, 1925*

Bell

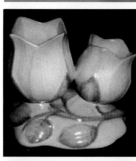

1715

Daffodil

1732

Arum Lily

1740, 1855

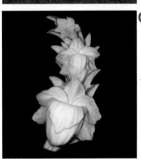

Gladioli

1744

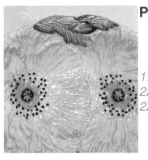

Poppy

*1746, 1872, 2010, 2241, 2257,
2263, 2276, 2278, 2284, 2288,
2289, 2293*

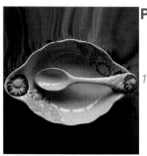

Pyrethrum

1751

Wallflower

1752, 1995

Clover/Shamrock

1754, 1874

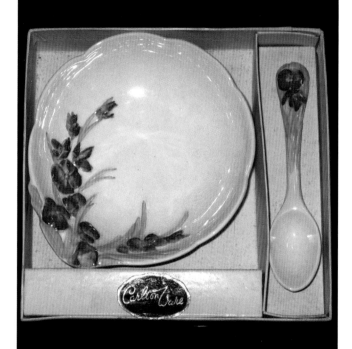

Wallflower

185

Narcissus

1764, 1767

Begonia

1768

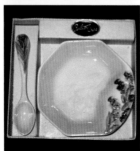

Forget-me-not

1769

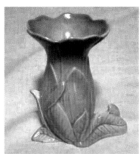

Campion

1771, 1873

Margarite

1867

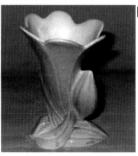

Lily

1868

187

Foxglove

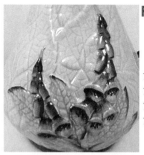

1870, 1875, 1879, 1881, 1882, 1883, 1884, 1885, 1886, 1887, 1888, 1890, 1895, 1896, 1897, 1898, 1903, 1904

Dogshead

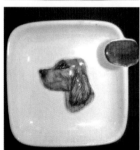

1914, 1915, 1917

Clematis

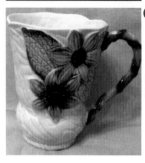

1952, 1953, 1957, 1958, 1959, 1962, 1963, 1964, 1968

Primula

1975, 1982, 2005, 2012, 2036, 2038, 2039, 2040, 2041, 2048, 2049, 2052

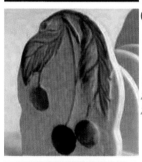

Cherry

1991, 2109, 2127, 2128, 2129, 2130, 2133, 2134, 2135, 2136, 2158

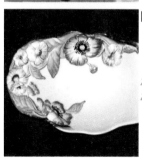

Poppy and Daisy

2018, 2034, 2037, 2042, 2051, 2053, 2054, 2056, 2067, 2069

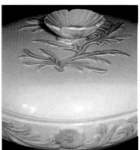

Buttercup, Late

*2030, 2047, 2055, 2057, 2058,
2059, 2061, 2066, 2068, 2074*

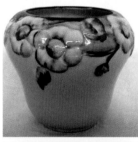

New Daisy

2043, 2044, 2046

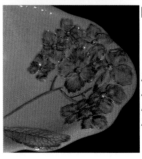

Hydrangea

*2086, 2154, 2161, 2165, 2167,
2169, 2170, 2171, 2172, 2173,
2174, 2176, 2209, 2210, 2219,
2261, 2264*

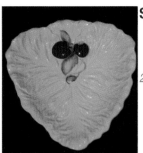

Salad Ware

2092, 2093, 2095, 2096

Langouste or Lobster

2125, 2242, 2470, 2492

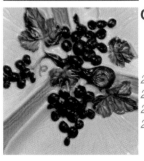

Grape

*2195, 2197, 2203, 2211, 2214,
2217, 2220, 2221, 2224, 2225,
2226, 2227, 2228, 2253, 2268,
2283, 2296*

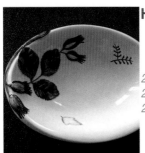

Hazel Nut

2277, 2306, 2307, 2310, 2311, 2313, 2316, 2318, 2326, 2330, 2357, 2358

Guinness

2300, 2637, 2705

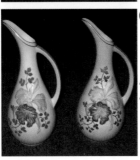

Orchid

2338, 2533, 2574, 2577, 2579, 2582, 2585

Convolvulus

2390, 2480, 2484, 2485, 2488,
2489, 2491, 2494, 2495, 2496,
2497, 2500, 2501, 2507, 2508,
2509, 2511, 2512, 2517, 2518,
2520, 2521, 2523, 2524, 2537

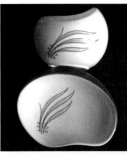

Windswept

2394, 2395, 2396, 2403, 2404,
2405, 2406, 2407, 2408, 2409,
2411, 2414, 2415, 2416, 2422,
2423, 2424, 2425, 2426, 2428,
2432, 2438, 2449

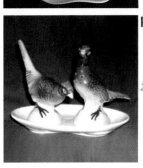

Pheasants

2400

Pinstripe

2419, 2429, 2430, 2435, 2439, 2451, 2452, 2453, 2454, 2455, 2456, 2461, 2465, 2466

Fruit

Includes Apple, Pear, Lemon, Pineapple, Vegetable, Tomato, Banana, Strawberry, Raspberry, Blackberry, Peach, Plum and Orange

2431, 2514, 2526, 2527, 2528, 2529, 2530, 2591, 2630, 2635, 2661, 2662, 2769, 2771, 2772, 2773, 2774, 2775, 2776, 2777, 2778, 2779, 2780, 2781, 2782, 2783, 2784, 3063, 3064, 3065, 3066, 3067, 3255, 3277, 3296, 3297, 3312, 3340

Squirrel

2503

Magnolia

*2515, 2531, 2553, 2558, 2559,
2560, 2562, 2563, 2566, 2571,
2588, 2592, 2593, 2594, 2595,
2597, 2598, 2604, 2605, 2607,
2611, 2615, 2616, 2617, 2618,
2621, 2622, 2623, 2624, 2627*

Aladdins Lamp

Appears with a variety of different patterns.

2525

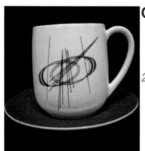

Orbit

2644, 2658, 2664, 2667, 2677

Carlton Village

Inn, Smithy, Water Mill, Wind Mill, Church, Cottage, Butter Market, Shop, Hall.

2645, 2646, 2647, 2648, 2649, 2650, 2651, 2652, 2653

Tapestry

2710, 2713, 2734, 2737, 2742, 2744

Daisy Chain

2716, 2717, 2718, 2729, 2730, 2731, 2747

Military Figures

2824, 2861

Skye

2850

Vine

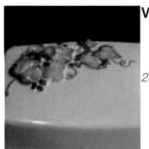

2907

Money Box - Flat Back

Owl, Horse, Cat, Ark, Engine, Face, Pig, Soldier, Boot, Peacock.

2922, 2923, 2944, 2946, 2950, 3080, 3086, 3104, 3141, 3142

Sunflower

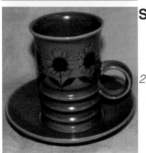

2992

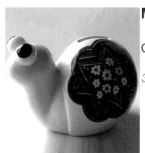

Money Box - Bug Eyes

Owl, Snail, Bird, Frog.

3128, 3129, 3130, 3131

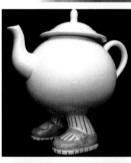

Walking Ware

Walking Ware, Running, Jumping and Standing Still Ware, Big Feet, Caribbean, Birthday Mugs, Royal Commemorative Ware.

3143, 3194, 3373, etc

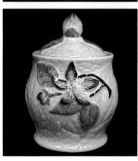

Apple Blossom - Arthur Wood

3175, 3176, 3178, 3179, 3180, 3182, 3183, 3185, 3186, 3188, 3189, 3192

Flow Blue - Arthur Wood

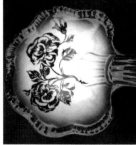

3177, 3181, 3184, 3187, 3190, 3191, 3193, 3200, 3202, 3203, 3204, 3205, 3206, 3216, 3223, 3224

Pig

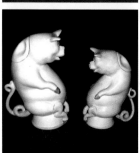

3271

Hovis

3273 etc

Index of Pattern Numbers

The following is a list of Pattern Numbers together with the page on which a picture of that pattern (ignoring the colour) appears. Occasionally two page numbers may appear because there are two (or more) patterns with that number or two pictures of that pattern.

4292 - *p149*	4357 - *p37*	4416 - *p49*
4293 - *p135*	4362 - *p49*	4417 - *p37*
4297 - *p152*	4366 - *p142*	- *p147*
4298 - *p152*	4367 - *p152*	4418 - *p78*
4310 - *p152*	4368 - *p154*	4419 - *p49*
4313 - *p135*	4369 - *p154*	4420 - *p142*
4314 - *p151*	4372 - *p78*	4421 - *p152*
4320 - *p49*	4373 - *p43*	4422 - *p43*
4322 - *p78*	4375 - *p154*	- *p147*
4324 - *p78*	4377 - *p148*	4423 - *p154*
4325 - *p135*	4379 - *p78*	4426 - *p80*
4326 - *p135*	4380 - *p147*	4433 - *p43*
4327 - *p142*	4385 - *p154*	4434 - *p43*
4328 - *p49*	4387 - *p154*	4435 - *p155*
4329 - *p49*	4388 - *p155*	4436 - *p155*
4330 - *p142*	4389 - *p155*	4437 - *p37*
4331 - *p142*	4391 - *p155*	4439 - *p142*
4332 - *p135*	4393 - *p124*	4440 - *p152*
4339 - *p152*	4395 - *p154*	4441 - *p154*
4340 - *p152*	4397 - *p37*	4442 - *p78*
4341 - *p37*	4398 - *p49*	4443 - *p152*
4342 - *p152*	4399 - *p142*	4444 - *p154*
4343 - *p152*	4400 - *p152*	4455 - *p156*
4344 - *p152*	4401 - *p147*	4457 - *p156*
4346 - *p49*	4402 - *p154*	4458 - *p156*
4347 - *p142*	4404 - *p78*	4459 - *p156*
4348 - *p152*	4405 - *p154*	4475 - *p156*
4350 - *p37*	4406 - *p78*	4480 - *p154*
4355 - *p127*	4408 - *p78*	4481 - *p154*
4356 - *p37*	4411 - *p154*	4484 - *p37*

Index of Shape Numbers

The following is a list of Impressed or Shape Numbers together with the page on which an example of that pattern appears, ignoring the colour and shape. Because of space restrictions we only show one shape to indicate the pattern.

2061 - *p190*	2133 - *p189*	2227 - *p191*
2066 - *p190*	2134 - *p189*	2228 - *p191*
2067 - *p189*	2135 - *p189*	2241 - *p183*
2068 - *p190*	2136 - *p189*	2242 - *p191*
2069 - *p189*	2154 - *p190*	2253 - *p191*
2074 - *p190*	2158 - *p189*	2256 - *p178*
2086 - *p190*	2161 - *p190*	2257 - *p183*
2092 - *p191*	2165 - *p190*	2261 - *p190*
2093 - *p191*	2167 - *p190*	2263 - *p183*
2095 - *p191*	2169 - *p190*	2264 - *p190*
2096 - *p191*	2170 - *p190*	2266 - *p178*
2100 - *p180*	2171 - *p190*	2268 - *p191*
2108 - *p180*	2172 - *p190*	2276 - *p183*
2109 - *p189*	2173 - *p190*	2277 - *p192*
2114 - *p180*	2174 - *p190*	2278 - *p183*
2115 - *p180*	2176 - *p190*	2283 - *p191*
2116 - *p180*	2195 - *p191*	2284 - *p183*
2117 - *p180*	2197 - *p191*	2288 - *p183*
2118 - *p180*	2203 - *p191*	2289 - *p183*
2120 - *p180*	2209 - *p190*	2293 - *p183*
2121 - *p180*	2210 - *p190*	2296 - *p191*
2122 - *p180*	2211 - *p191*	2300 - *p192*
2123 - *p180*	2214 - *p191*	2306 - *p192*
2124 - *p180*	2217 - *p191*	2307 - *p192*
2125 - *p191*	2219 - *p190*	2310 - *p192*
2127 - *p189*	2220 - *p191*	2311 - *p192*
2128 - *p189*	2221 - *p191*	2313 - *p192*
2129 - *p189*	2224 - *p191*	2316 - *p192*
2130 - *p189*	2225 - *p191*	2318 - *p192*
2132 - *p180*	2226 - *p191*	2326 - *p192*

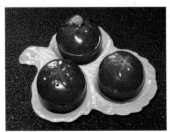

THE CARLTON WARE COLLECTION

The web site for all things Blush from Carlton Ware.

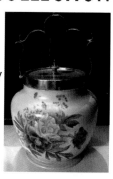

My collecting passion is for Blush Ware from the Wiltshaw and Robinson factory made from 1890 to 1910. Fed up with trailing around fairs and web sites finding the odd piece here and there, I decided to set up my own web site where I could buy and sell the kind of items I would want and share pieces with other collectors.

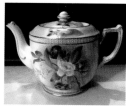

All pieces on the site have either been purchased by me to sell on or come from my own collection.

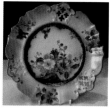

The range includes hard to find Plates, Tea Pots, Dishes, Biscuit Barrels and Sugar Sifters, to name a few. All items are **very competitively priced** and even if it's not on the site, I may have what you are looking for or know where to find it.

Have a browse around the site at
www.thecarltonwarecollection.com
or you can contact me on
mmaunder@jlt.org.uk

Gazelles Ltd.

Decorative Arts & Art Deco Specialist
large comprehensive stock - worldwide delivery - established 1984

Web Site: www.gazelles.co.uk
email: allan@gazelles.co.uk
Tel: 02380 811610 International +44
Mobile: 07778 020104 International +44
Fax: 0845 2802148 International +44.